moments**HOME**nationalge
ts**HOME**nationalgeographicmomentor
OMEnationalgeographicmoments**HOME**
eographicmoments**HOME**nationalgeo
aphicmoments**HOME**nationalgeograph
oments**HOME**nationalgeographicmom
MEnationalgeographicmoments**HOME**n
nalgeographicmoments**HOME**national
lgeographicmoments**HOME**nationalge
icmoments**HOME**nationalgeographicm
ts**HOME**nationalgeographicmoments**H**
geographicmoments**HOME**nationalgec
cmoments**HOME**nationalgeographicmc
ts**HOME**nationalgeographicmoments**H**
tionalgeographicmoments**HOME**natior
raphicmoments**HOME**nationalgeograp
oments**HOME**nationalgeographicmom
OMEnationalgeographicmoments**HOME**

To:
My great friend

From:
Rosie

national geographic *moments*

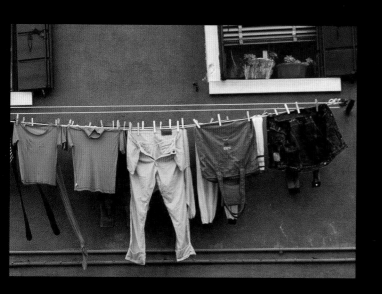

HOME

by K. M. Kostyal

NATIONAL GEOGRAPHIC

Washington, D. C.

Home. Like love, it's one of the most complicated ideas we humans hold dear. At home, back home, far from home, away from home—all phrases that conjure images of a physical space, an emotional moment, a remembered place, a country, a family, a time. As the photographs in this collection from National Geographic's archives show, home is all of these things, and more. ❧ What is most surprising in the scenes that follow is the endless ways we humans have of constructing and construing "home." From the tidy frame homes and picket-

Home

fence yards of an American town to the portable yurts of nomads on the barren steppes of Mongolia, homes come in all shapes and sizes. ❧ Most historians would agree that what propelled people across the Atlantic to the wilds of the New World in the 17th century was the promise of home ownership. Those first arrivals often lived in cramped and dank stockaded villages and later in small, dark cabins—cold in winter, stifling in summer. Later generations of Americans, pushing West into the unforgiving prairie, settled for one-room shelters made of the thing most available to build with—sod. ❧ American homes have improved immeasurably since

then, and home comfort, for much of the industrialized world, has reached historic heights, with running water, indoor plumbing, electricity, climate control, even an endless stream of built-in entertainment— radio, TV, DVD, Internet. And yet to many in the world, these luxuries remain beyond imagination. ❧ The photographs in this book document the last century of home styles worldwide, and what is remarkable is how little—or sometimes how much—homes have changed for different peoples. In many of the forests of Asia, home is what it has been for centuries—a bamboo hut on stilts. To many of the inhabitants of Central and South America, it remains a simple adobe, most often with a dirt or concrete floor. And the Aymara high up on the shores of Lake Titicaca still build their simple shelters of reed mats. Simple, maybe, but with the same promise of safety, family, and security as the suburban American tract house. ❧ Yet things have changed dramatically for other groups, such as the American Indians of California. A 1914 image shows them still living in their conical grass huts. A life now long gone—and sometimes longed for as a panacea to the complicated present. In one unforgettable picture in the following chapters, a family of

Walla Walla Indians re-creates their past—sort of—in a current-day tepee set up at a powwow. Sunlight filters through the tent cloth, into a space with all the modern conveniences of home and the romance of the past. ❧ For the American Indians who shared that past and the Aymara and many of the traditional peoples the Geographic has long covered, climate and available materials dictated the shape and nature of home. If you lived in a tropical rain forest, then you built with local materials, as your ancestors did before you, and you built to stay cool, to keep out the rain. ❧ Tradition tends to flavor homebuilding everywhere, but in different ways. To the wealthy, looking to build a showcase house, materials may come from far and wide, but they are dictated by long-cherished notions of taste and opulence: Italian marble and Spanish tiles, the deep patina of imported dark woods from the tropics, carpets from Persia. Home decorating more to make a statement than to comfort or cosset. ❧ Architects, naturally, have found the home one of the most versatile and fast-changing forms of expression for their talents, particularly in America, where vast canvases of undeveloped land have beckoned aspiring homeowners and

developers. From the low-slung, Prairie-style houses of Frank Lloyd Wright to the East Coast colonial houses that echo their 18th-century Georgian predecessors to the Victorian houses of San Francisco and the sprawling adobes of the Southwest—American homes particularly express their regionalism, their architect, and their owner. ✢ In some cultures homes are open to the world, their verandas, rooftops, or courtyards connecting them physically to their neighbors and to the broader society. In other cultures, like those of Western Europe and the U.S., climate and culture conspire to build walls that enclose, almost fortresslike, the individual and family, guaranteeing privacy. Within those walls, away from the prying eyes of the outside, the family can create an insular kingdom of its own. ✢ But whatever the culture or style of life, it's the decorative touches that allow the dweller the greatest expression. In your space, your own home, you can put up your Elvis shrine, or honor your ancestors, or simply celebrate being alive. In one poignant picture from the slums of Bombay, a family has decorated their dilapidated entrance with strings of marigolds and leaves for the New Year. The children staring into the camera seem perfectly content. In this

small spot in this big, wild city, they have their own place, security, legitimacy. They are home. ❧ Obvious, too, in some of these photos is how sustainable the idea of home is. Wars, politics, economics, and religion frequently force people out of their home country, and when that happens emigrants invariably take their concept of home with them and re-create it in a new land. ❧ In a 1980s NATIONAL GEOGRAPHIC magazine article, a community of Old Believers, having left the Russian motherland behind to resettle in Alaska, manages to remake their new homes in the image of the old. That remaking happens every day, all over the world, when displaced people comfort themselves with the simple remembrances of their old lives in their new worlds. The simplest of touches can re-create the home that was left behind: pictures on the wall, doilies on a tabletop, the smell of familiar food cooking. ❧ Cooking and food, in fact, are themes recurring over and over in these photographs, no matter where in the world they were taken. Invariably the food theme also involves women: in the kitchen shaping the bread, stirring the pot, taking a break with a cup of tea or coffee. Or at the table, monitoring the family meal. Maybe food—its preparation, its

enjoyment, its shared force—is the ultimate expression of home. ❧
Home is, after all, where the heart is—and the memories, and for most
of us the moments of profoundest well-being. Most of the images that
follow make us want to walk into the scene ourselves, to join in it, or
just to observe it more closely. It's not the home—the structure—that
engages us. It's the human emotion collected around it and expressed
by those pictured, in a simple gesture of peace or caring or pride or
celebration, that invites us in. ❧

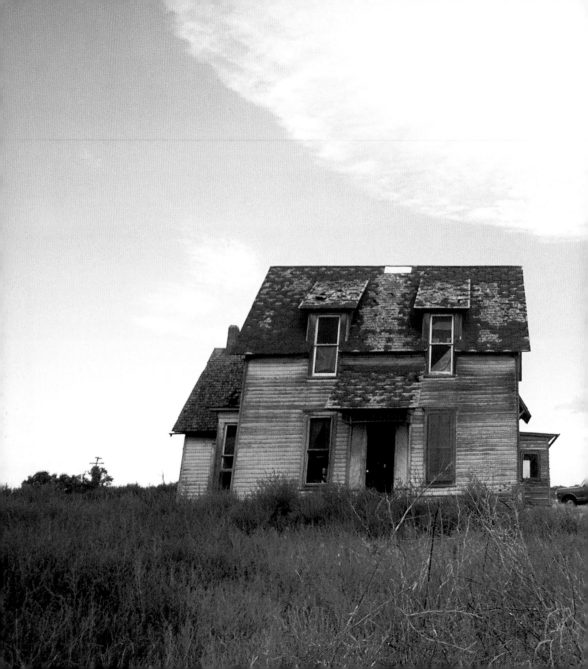

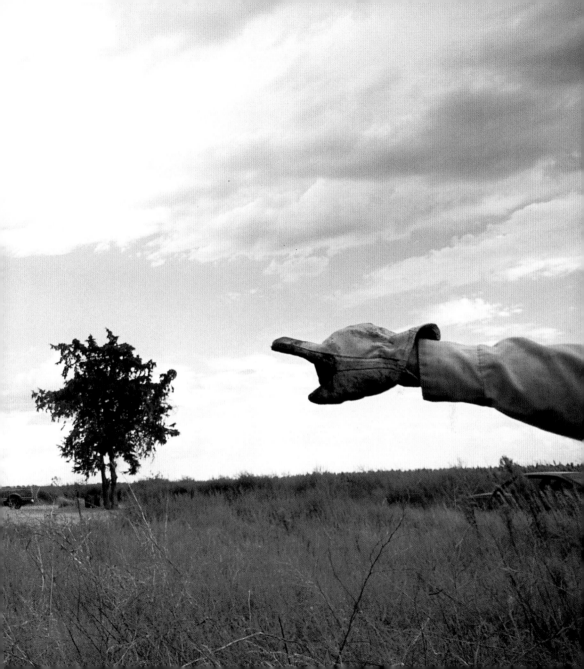

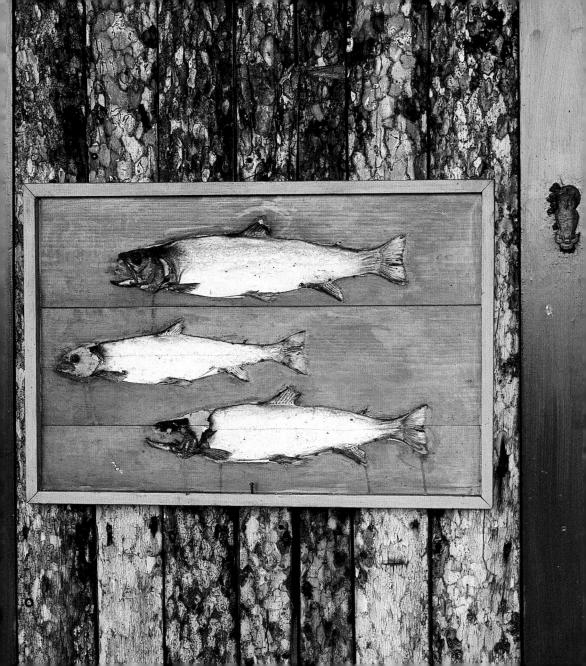

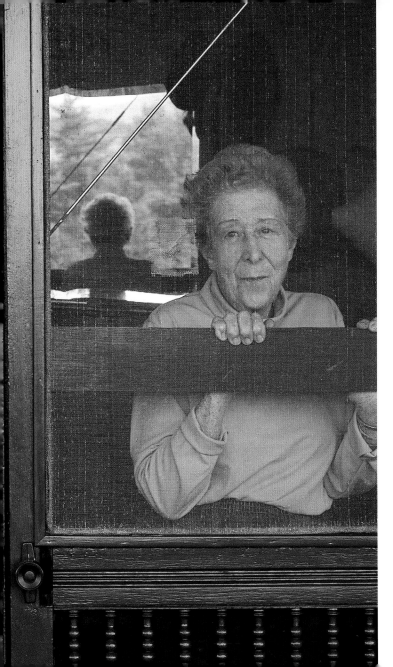

ADIRONDACK MOUNTAINS,
NEW YORK
1998
SAM ABELL

preceding pages
NEAR BELLEVILLE, KANSAS
1990
JOEL SARTORE

following pages
NEAR TIMBUKTU, MALI
1987
STEVE MCCURRY

SOLOMON ISLANDS
1916
J. W. BEATTIE

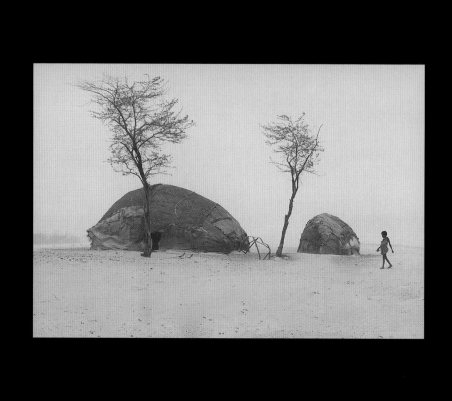

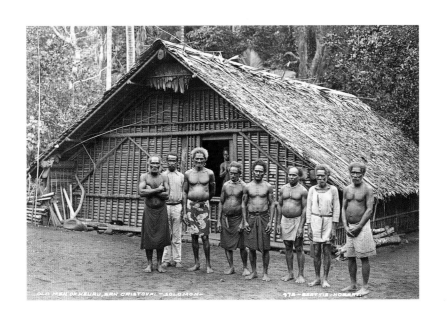

OLD MEN OF HEURU, SAN CRISTOVAL — SOLOMON — 375 — BEATTIE — HOBART.

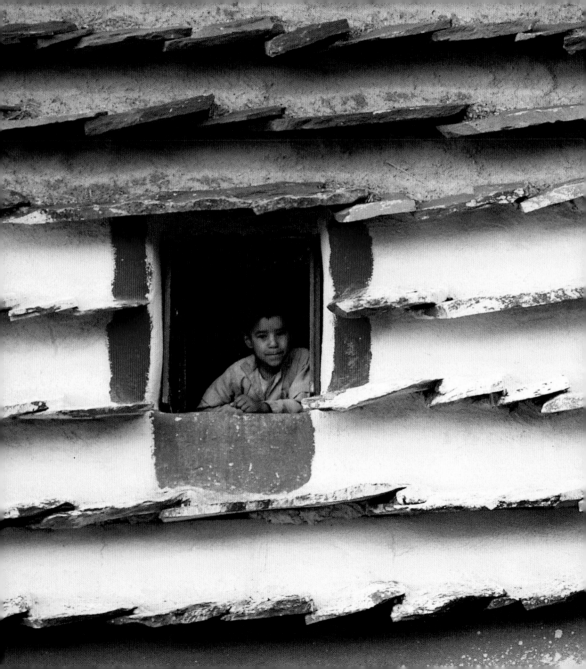

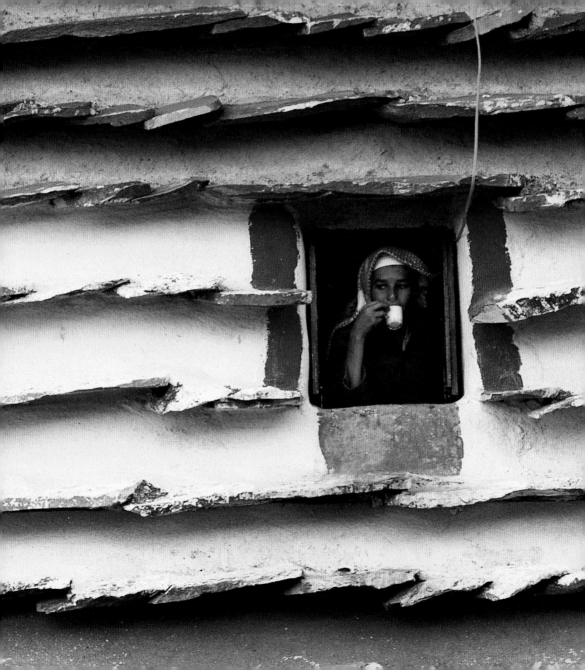

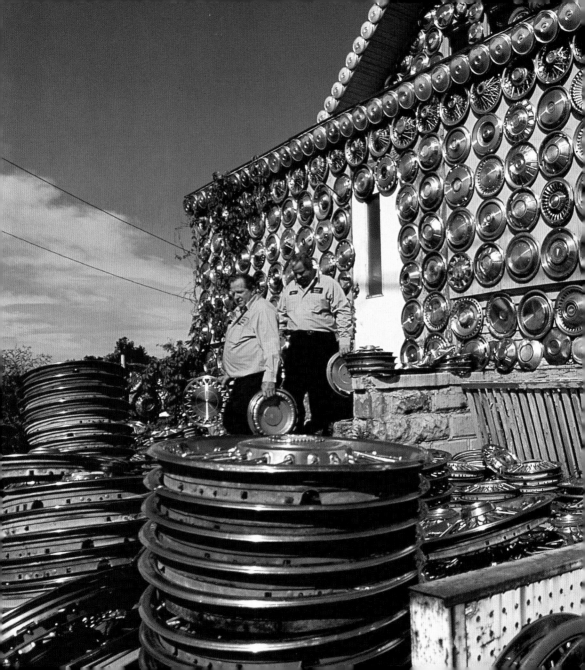

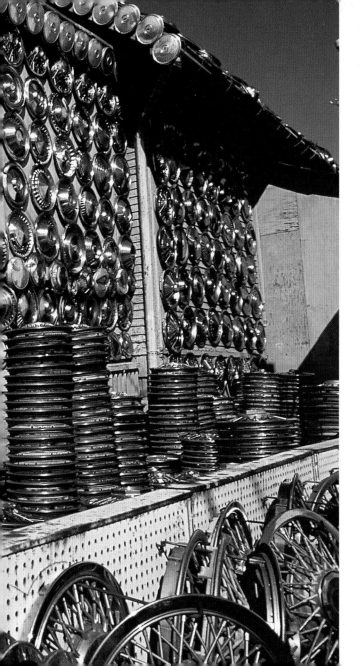

PEORIA, ILLINOIS
1998
TOMASZ TOMASZEWSKI

preceding pages
SAUDI ARABIA
1980
ROBERT AZZI

CALIFORNIA
1914
A. W. PETERS

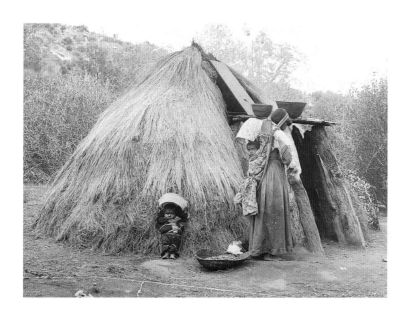

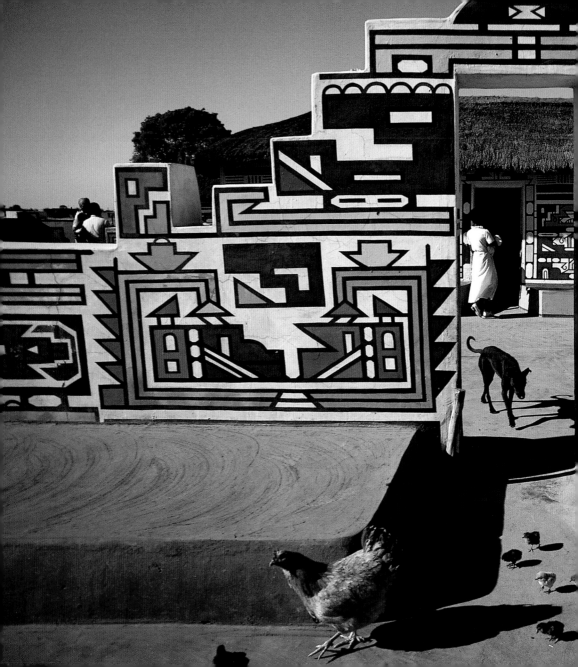

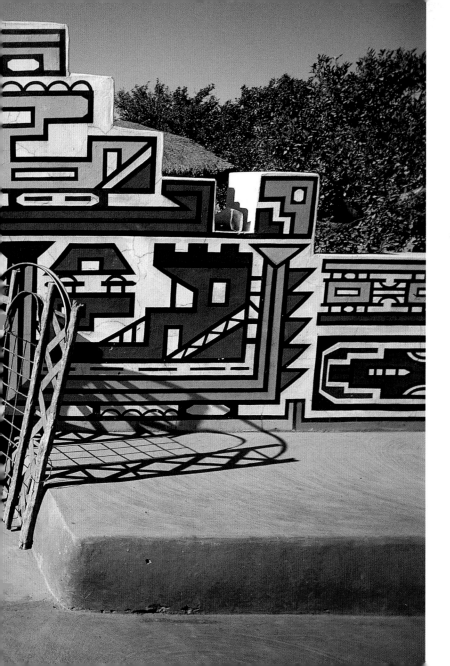

SOUTH AFRICA
1986
PETER MAGUBANE

NEW GUINEA
1929
E. W. BRANDES

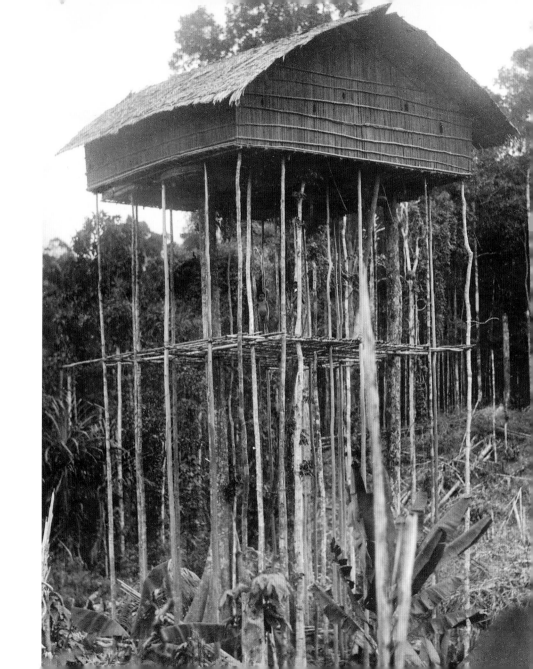

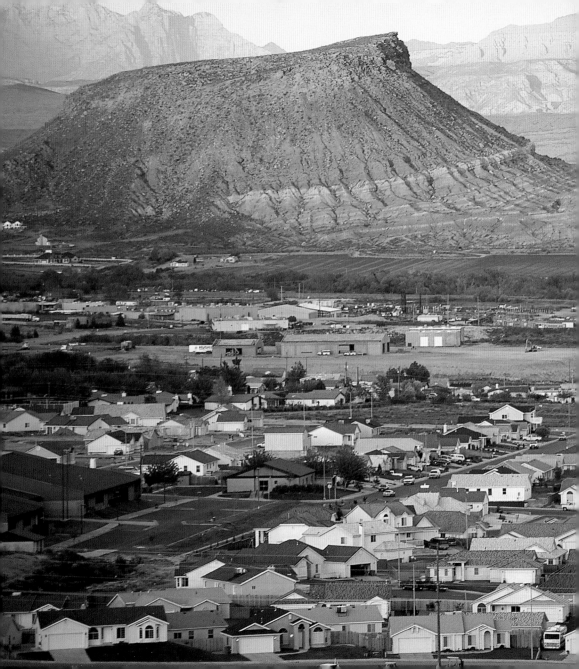

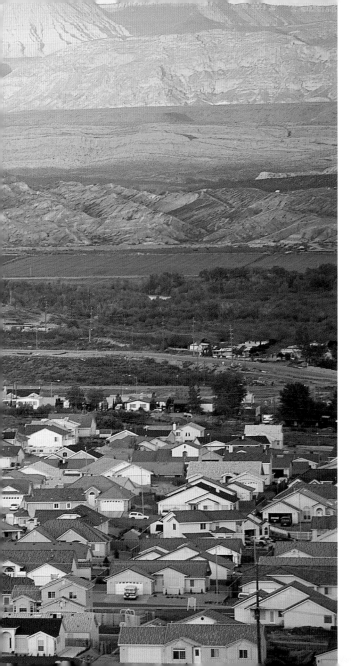

ST. GEORGE, UTAH
1995
JOEL SARTORE

TRINIDAD, CUBA
1999
DAVID ALAN HARVEY

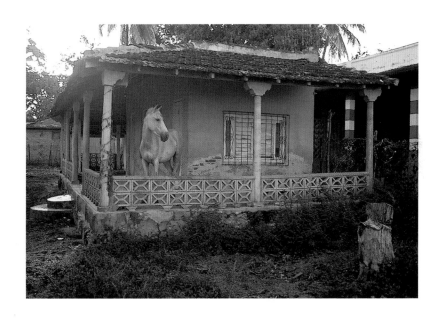

In the past, the workplace and h

omeplace were often the same place. For farm families, the home has always doubled as a kind of factory, where canning, churning, book-keeping, butchering, furniture-making, sewing, and weaving took place. In more recent times, cottage industries have been launched at kitchen tables, or computer empires in family garages, some of them becoming megabusinesses. Ironically, in the current age of technology, with its computers, faxes, and the Internet making it easy to maintain home offices, the workplace and homeplace are becoming one again. ❧

NIKOLAEVSK, ALASKA
1972
CHARLES O'REAR

following pages
MILWAUKEE, WISCONSIN
1980
MICHAEL MAUNEY

**LABRADOR,
NEWFOUNDLAND**
1993
RICHARD OLSENIUS

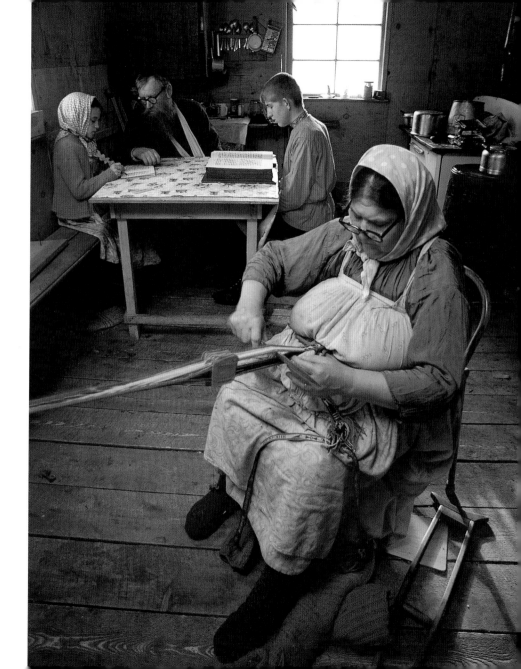

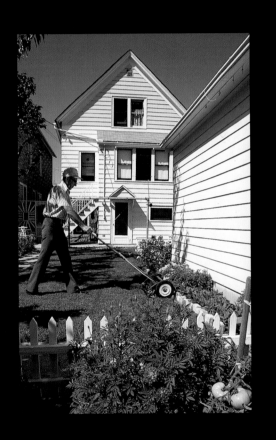

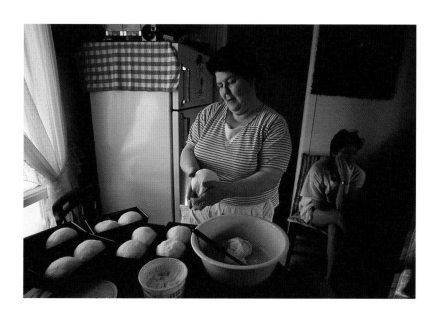

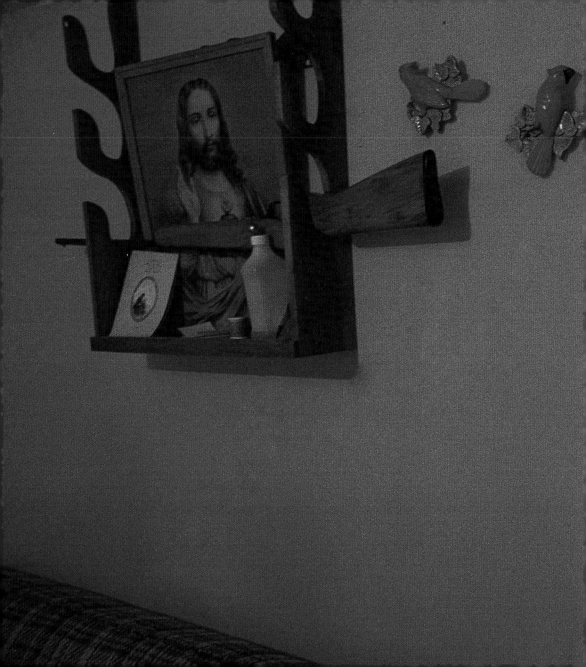

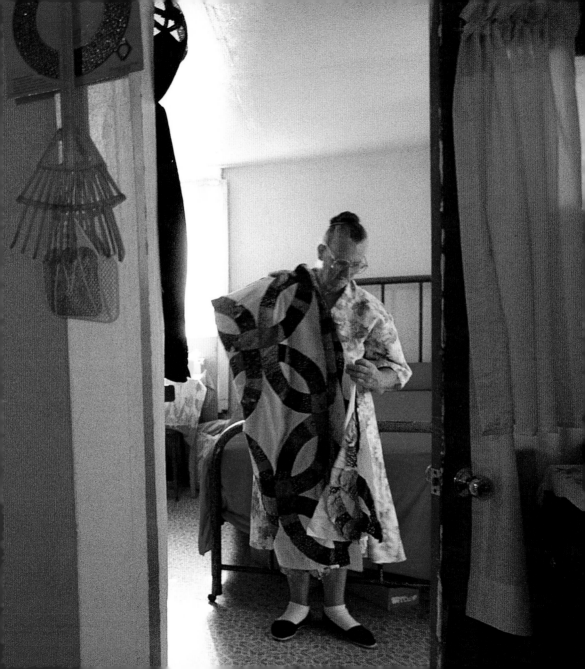

NEW DELHI, INDIA
1942
MAYNARD O. WILLIAMS

preceding pages
APPALACHIA
1993
KAREN KASMAUSKI

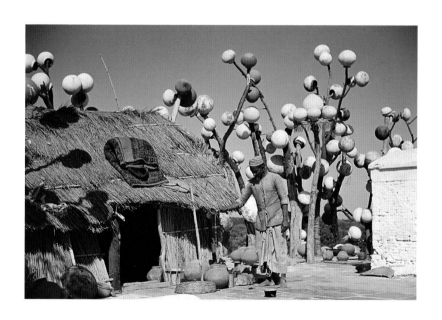

MOSCOW, RUSSIA
1997
GERD LUDWIG

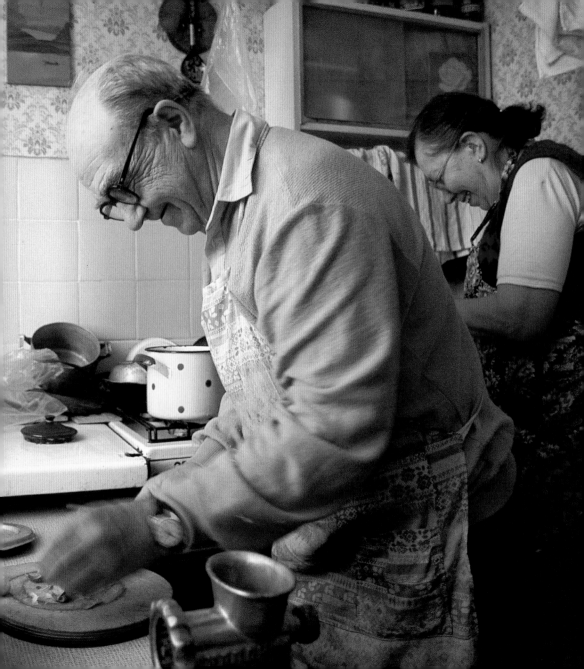

TRISTAN DA CUNHA
ISLAND
1964
JAMES P. BLAIR

following pages
SAN JOSE, CALIFORNIA
2001
BOB SACHA

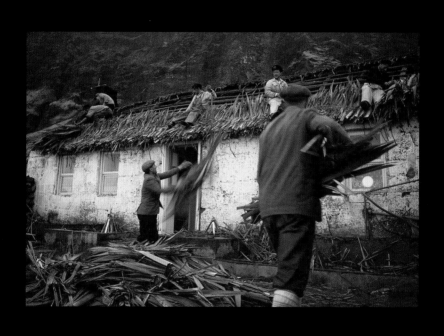

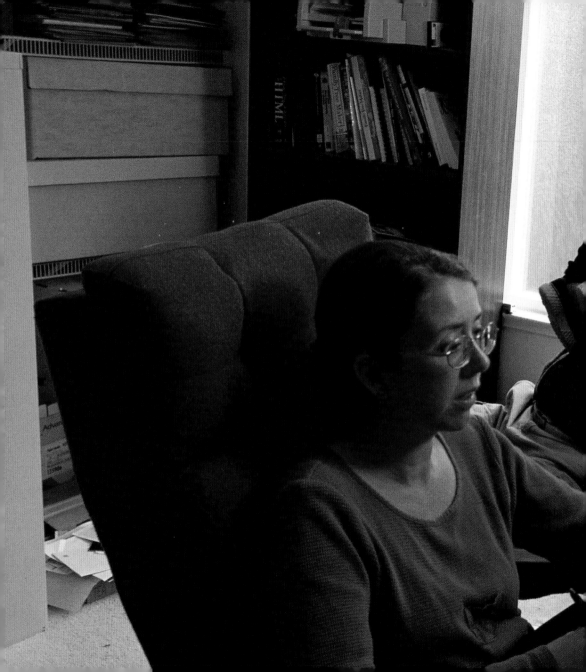

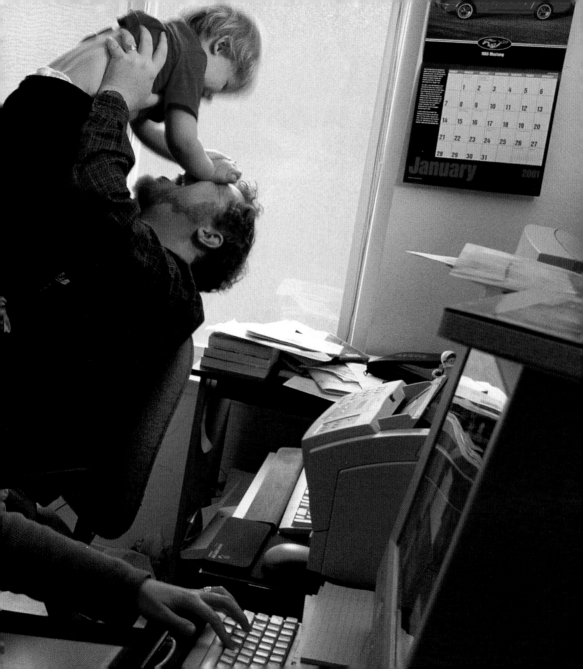

NEAR SAUGERTIES,
NEW YORK
1996
MELISSA FARLOW

following pages
PENDLETON ROUNDUP,
OREGON
1994
DAVID ALAN HARVEY

QUIANDEUA, BRAZIL
1997
JOEL SARTORE

MEKONG RIVER, VIETNAM
1993
MICHAEL YAMASHITA

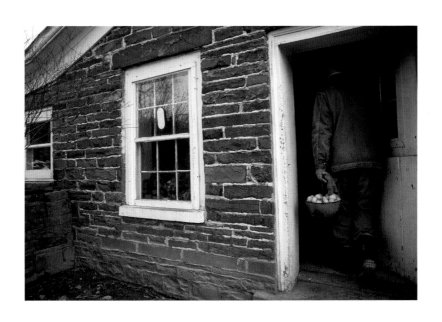

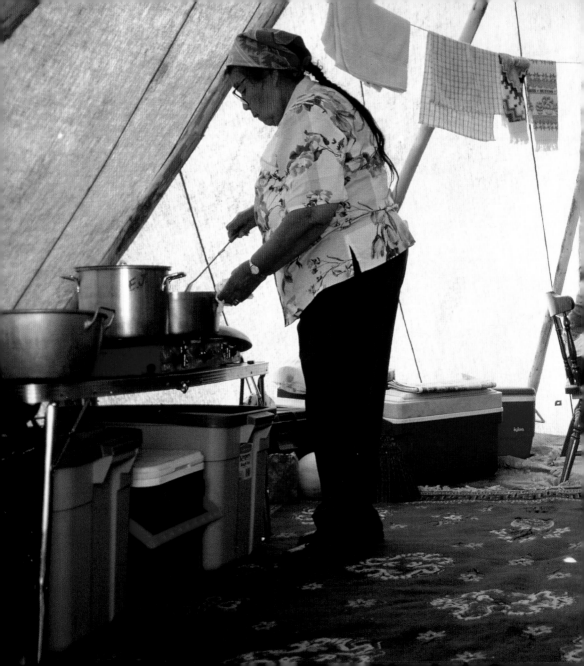

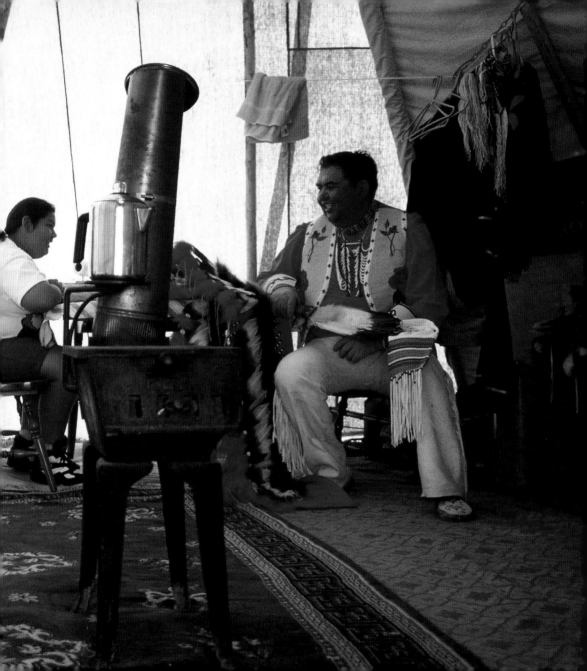

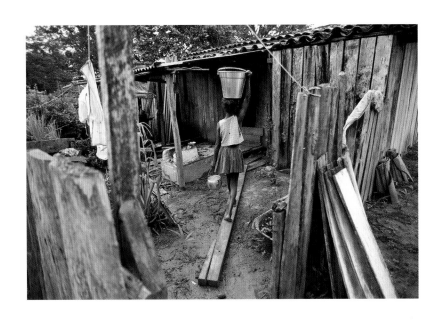

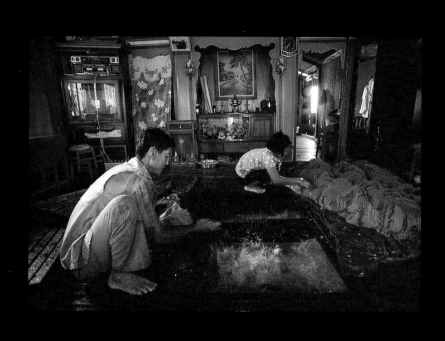

Living in style is the dream of almo

st all of us, though what "style" means varies hugely, as the following images attest. In an earlier age, the ultimate in style was the grand home, with its formal and impressively ornate rooms. Now, those manors and mansions are museum pieces, surely worthy of preservation and restoration, but often too cold and impersonal to convey the comforts of home. ❧

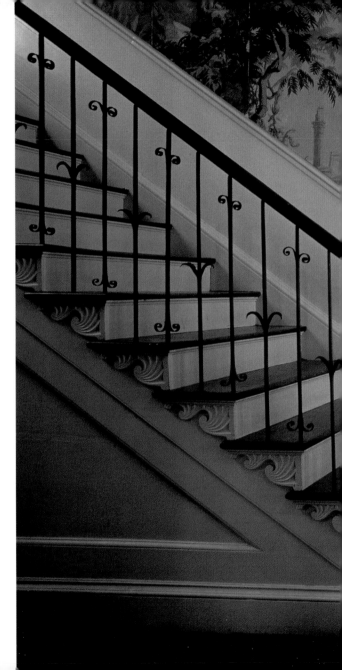

CHARLESTON,
SOUTH CAROLINA
DATE UNKNOWN
BOB SACHA

following pages
SARASOTA, FLORIDA
1991
JOEL SARTORE

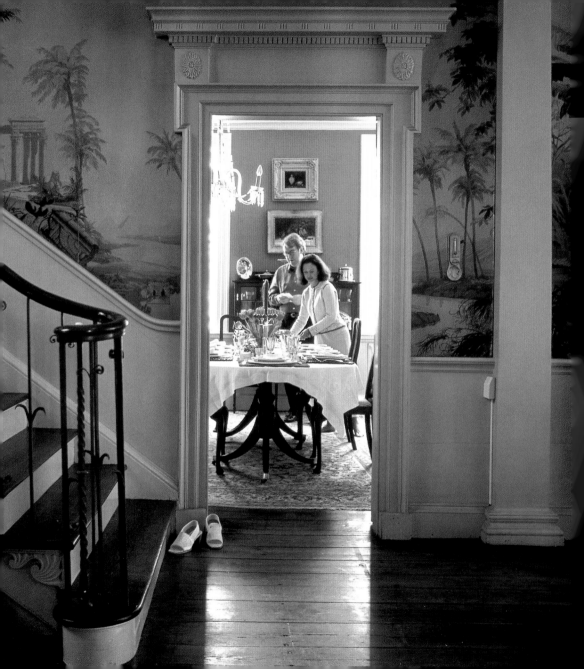

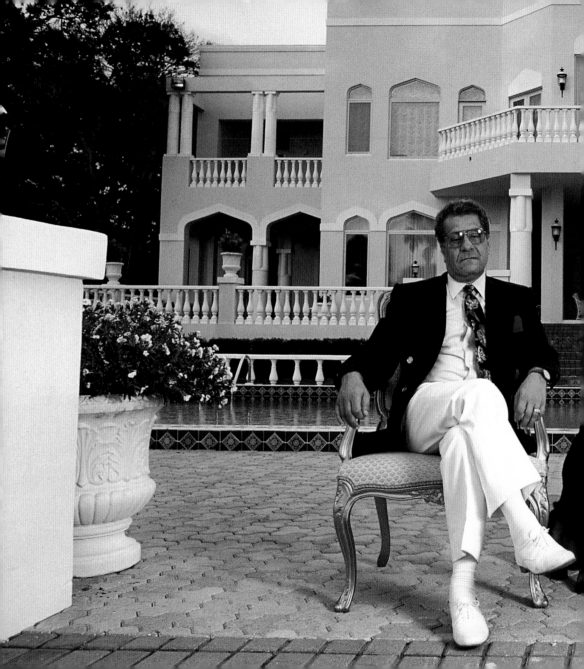

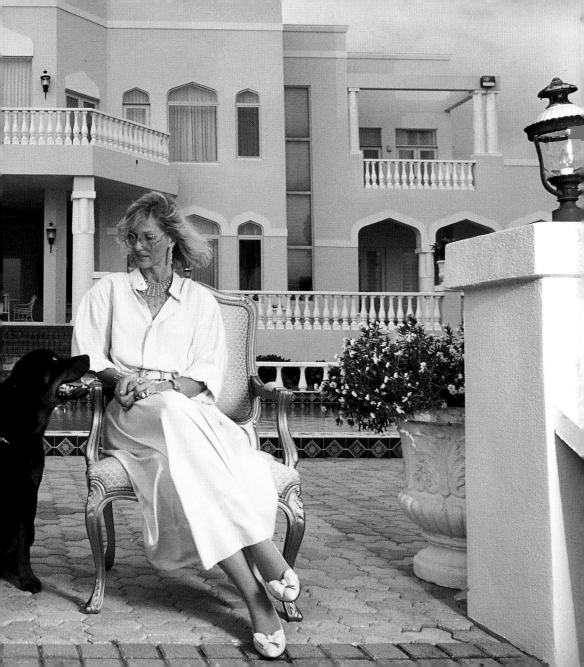

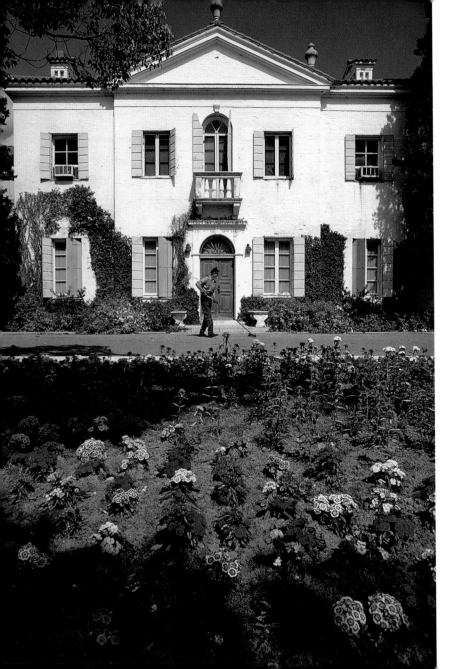

SEA ISLANDS, GEORGIA
1971
JAMES L. AMOS

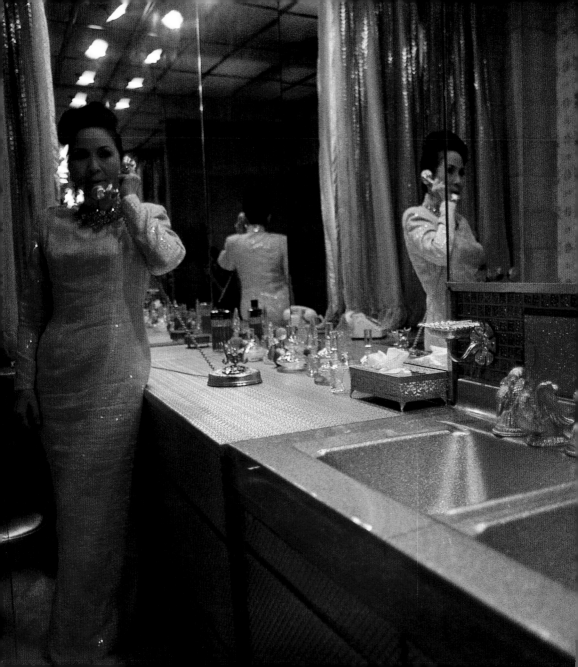

HONG KONG ISLAND
DATE UNKNOWN
JODI COBB

IRELAND
DATE UNKNOWN
GAIL MOONEY

following pages
MEXICO CITY, FEDERAL
DISTRICT, MEXICO
1984
STEPHANIE MAZE

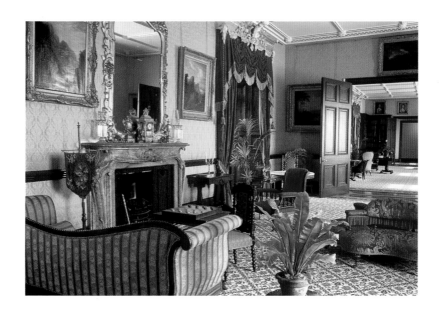

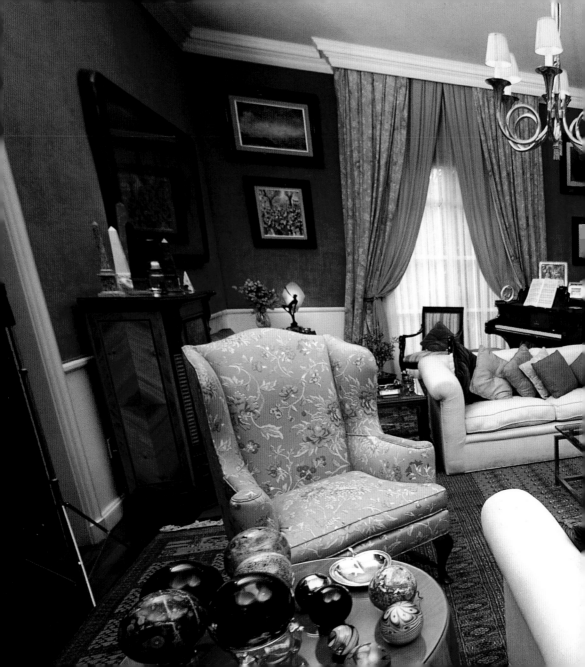

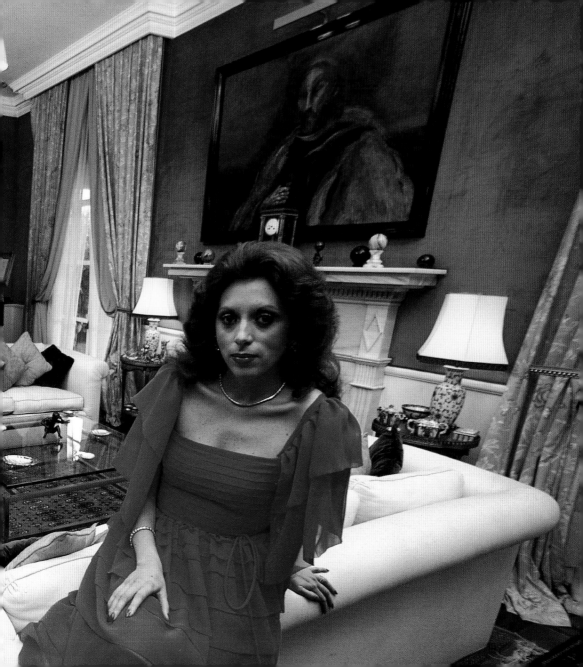

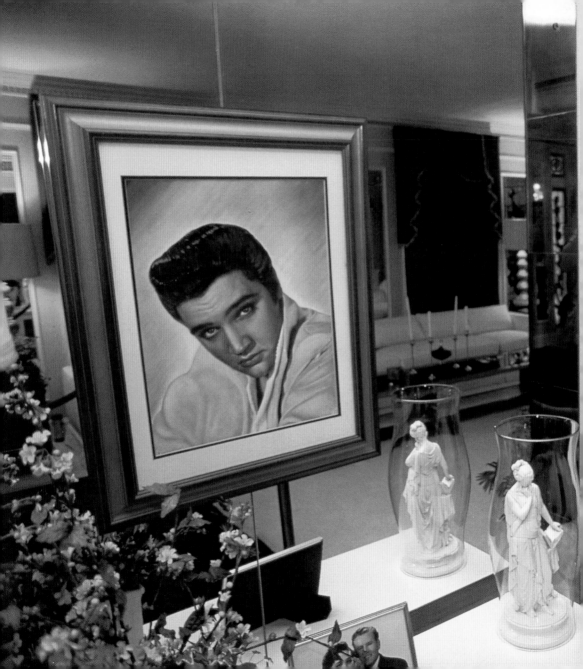

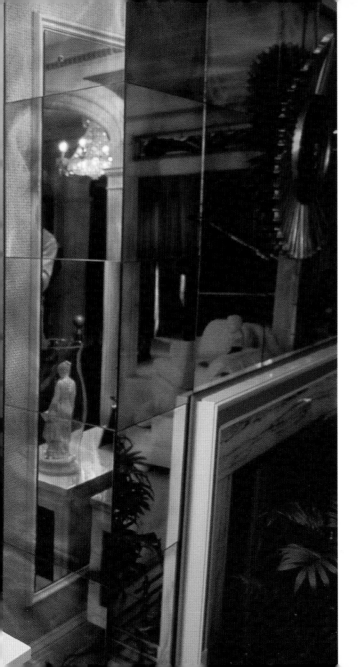

GRACELAND, MEMPHIS,
TENNESSEE
1996
RAYMOND GEHMAN

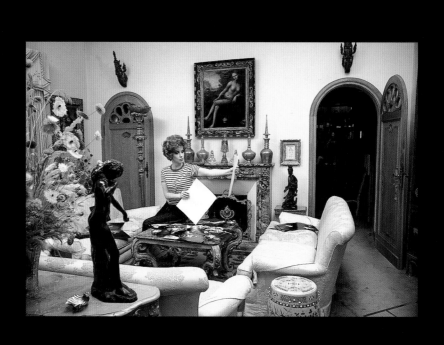

ROME, ITALY
1970
WINFIELD I. PARKS, JR.

NEAR DUBLIN, IRELAND
1981
COTTON COULSON

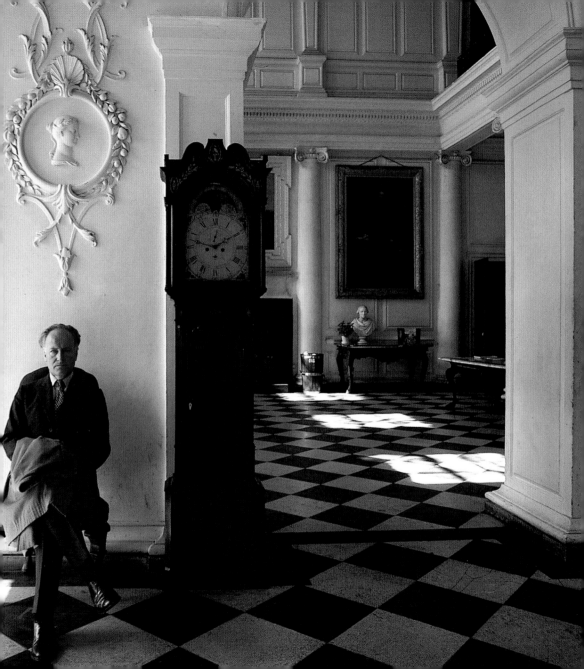

Portable homes may be the bes

kinds. There's just something romantic about the idea of picking up and moving your home when the whim strikes. Gypsy wagons, tepees, and yurts were built to be mobile. But the traditional nomadic life is, in many places, becoming a thing of the past, as land ownership encroaches on freedom of movement. Unless, of course, you have a modern mobile home. Then you can go wherever the paved road leads—and the electrical and plumbing hookups allow. ❧

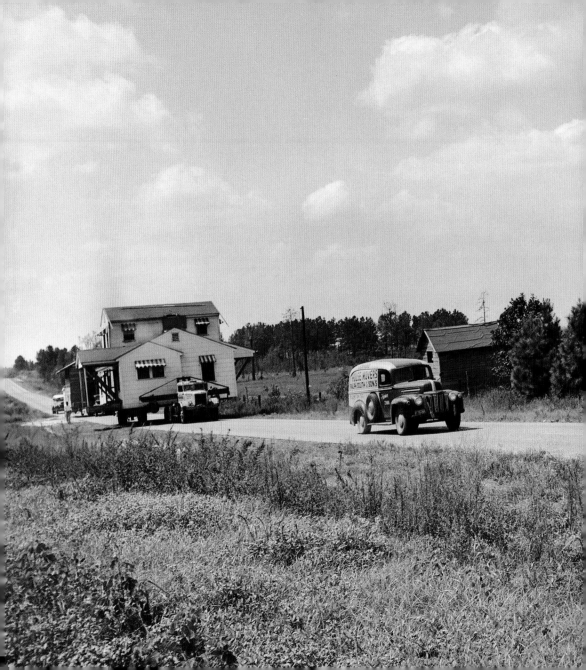

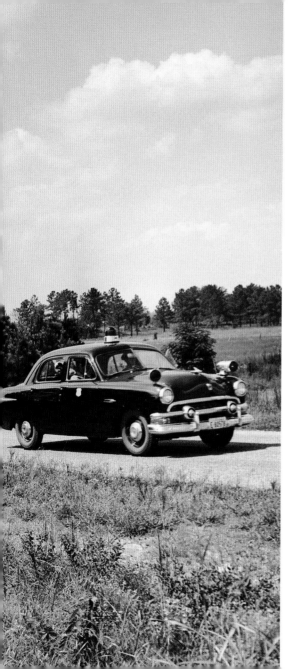

SOUTH CAROLINA
1952
GEORGE SCHAEFFER

following pages
APPLEBY, ENGLAND
1972
BRUCE DALE

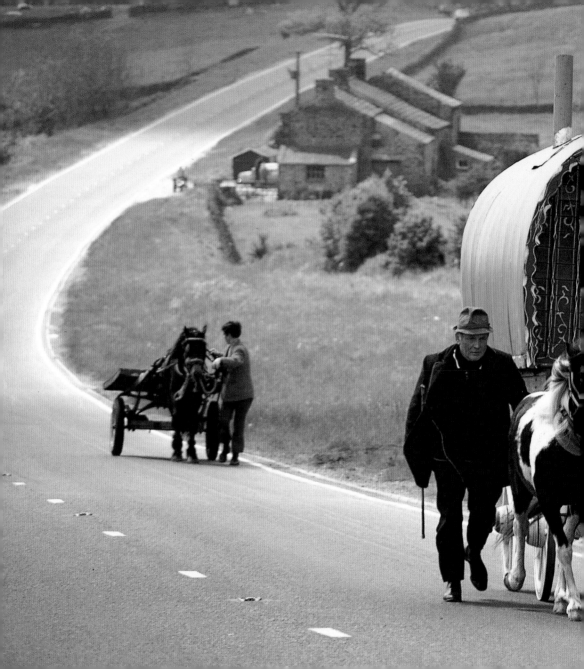

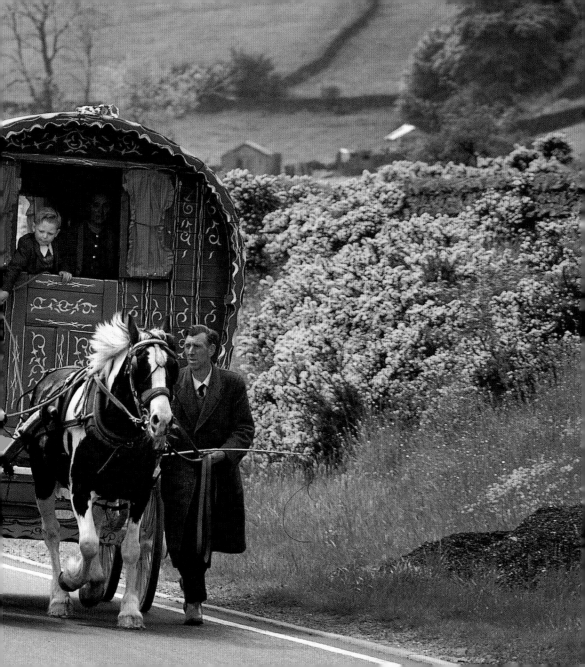

XINJIANG, CHINA
1996
REZA

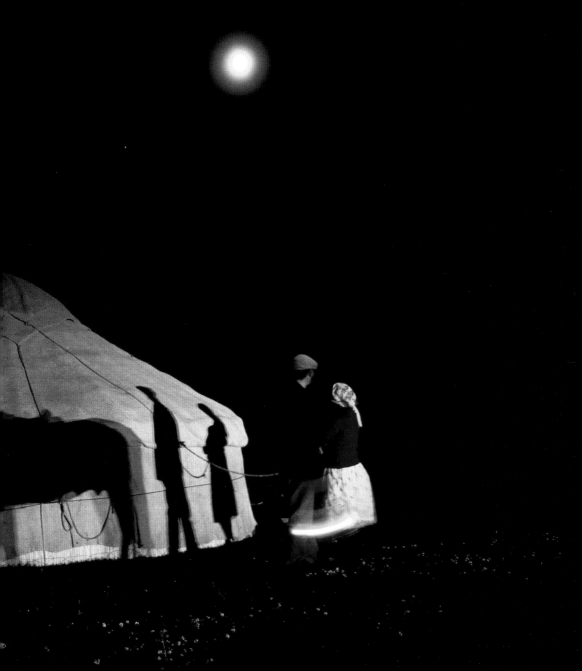

XINJIANG, CHINA
1936
EDWARD S. MURRAY

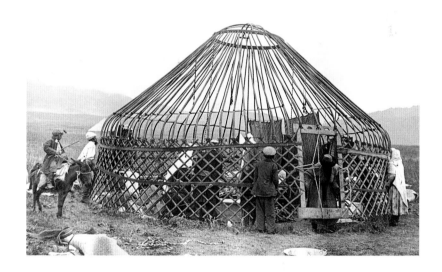

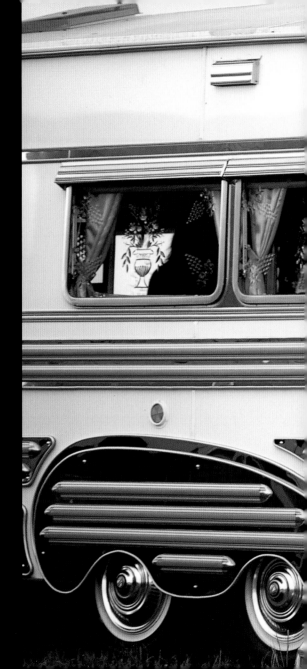

APPLEBY, ENGLAND
1972
BRUCE DALE

following pages
U.S.A.
1999
TOMASZ TOMASZEWSKI

BUZESCU, ROMANIA
DATE UNKNOWN

APPLEBY, ENGLAND
1972
BRUCE DALE

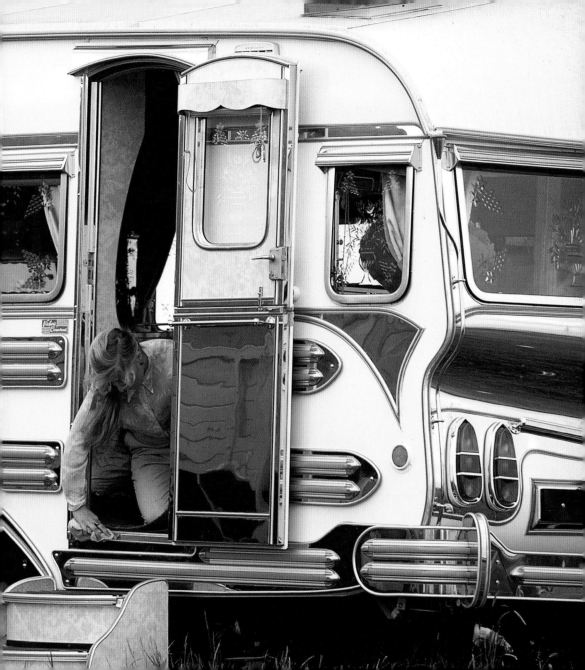

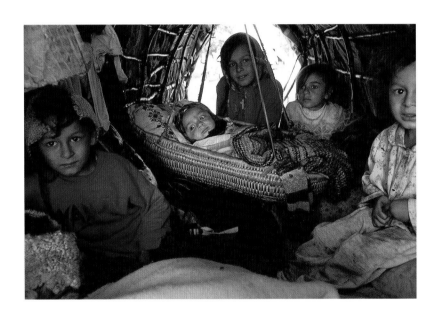

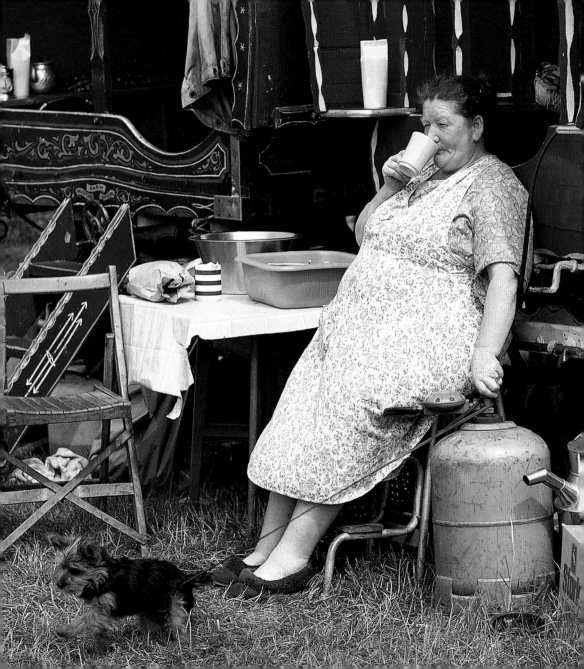

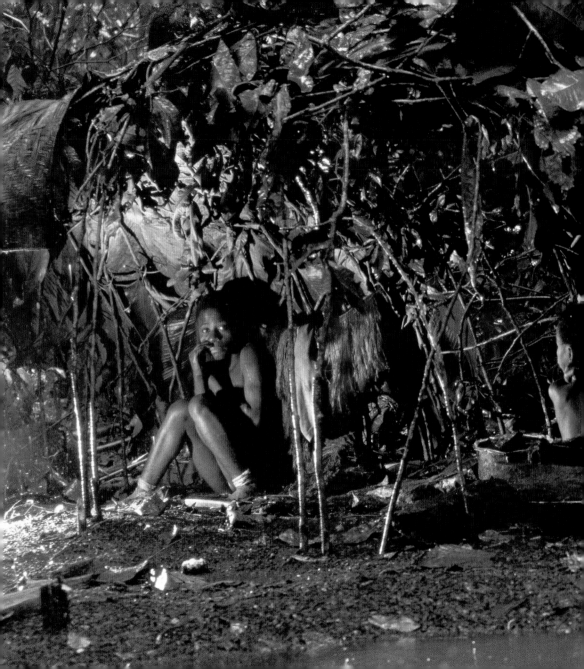

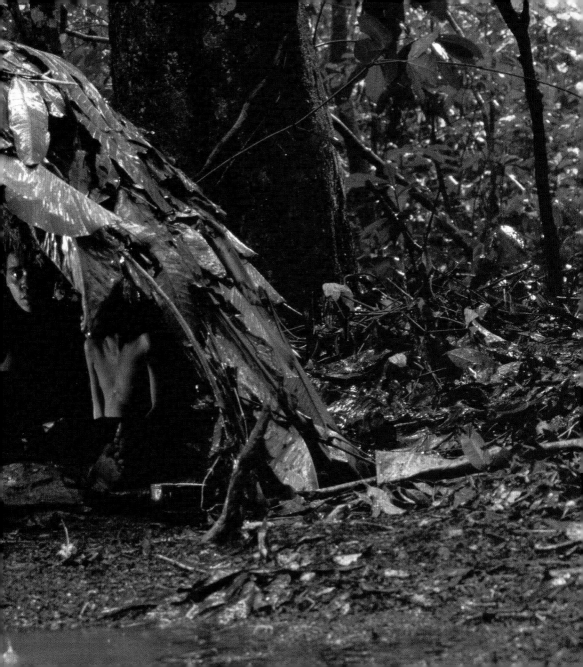

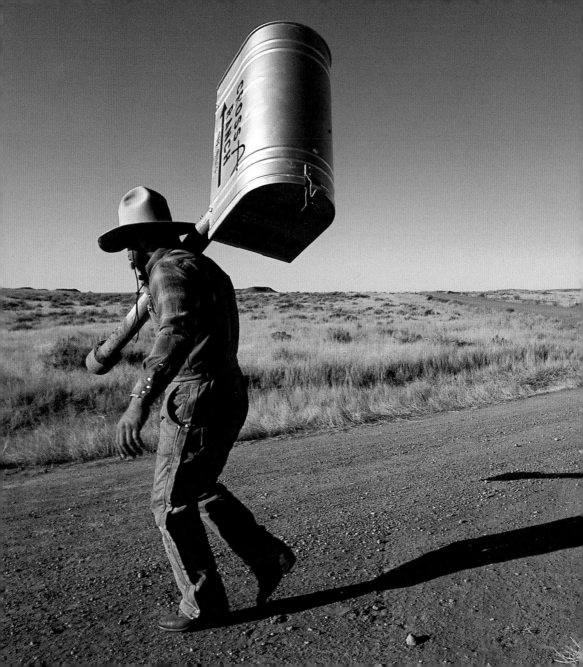

WYOMING
1993
RICHARD OLSENIUS

preceding pages
CONGO
2000
MICHAEL NICHOLS

Home and family—they're almost

synonymous. The home is, after all, simply the vessel that holds the family, and it has to conform to the shape and needs of the family. Where the family is an extended affair, home may be a complex, with wings or separate huts facing a shared courtyard, or "in-law" additions. Where nuclear families prevail, homes still need separate spaces—a place to cook and eat, to sleep, to bathe, or simply to gather. For a family of one, even a single room and bath can be enough, if it has that special quality called home.

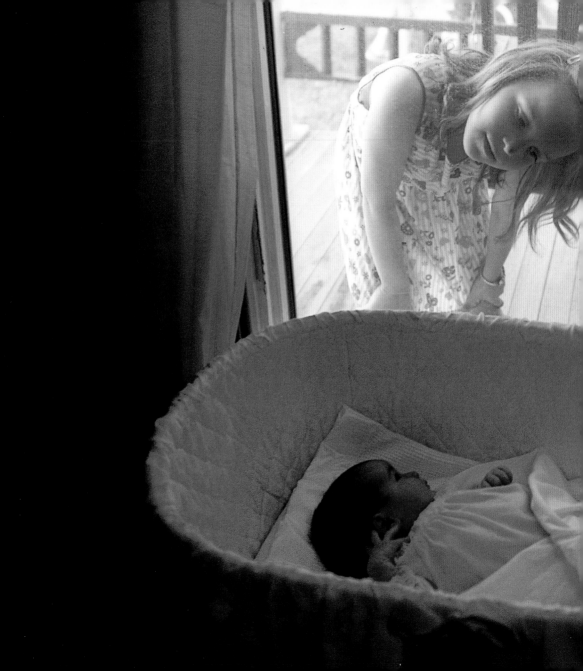

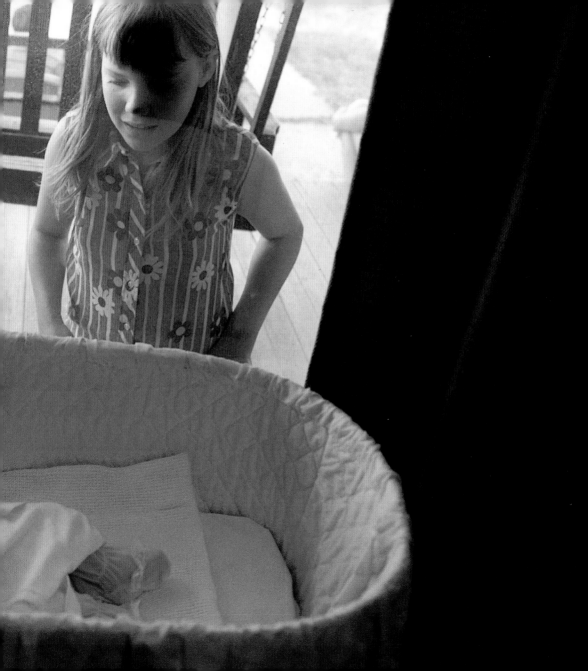

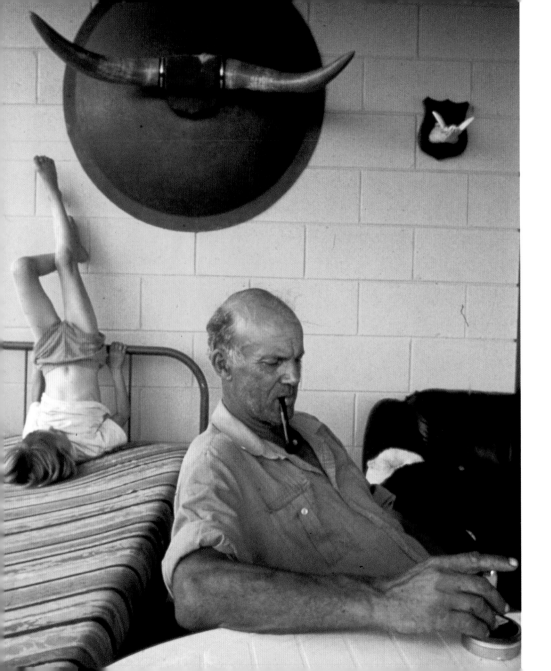

CAPE YORK PENINSULA,
AUSTRALIA
1996
SAM ABELL

preceding pages
HARTSBURG, MISSOURI
DATE UNKNOWN
H. EDWARD KIM

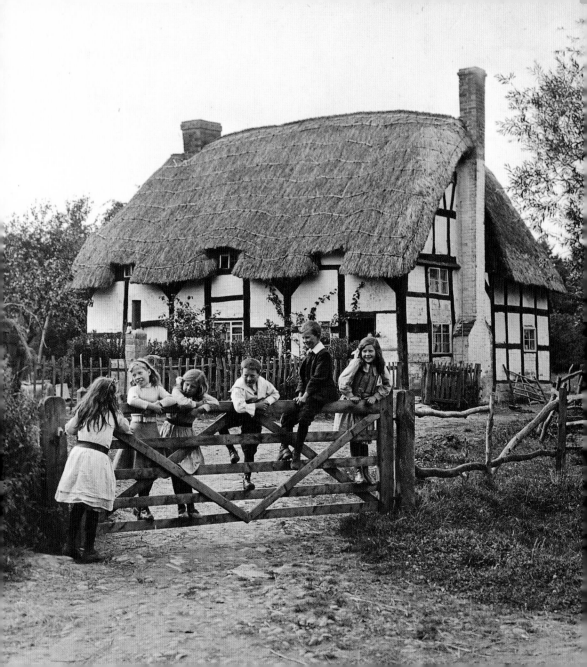

PEOPLETON,
WORCESTERSHIRE, ENGLAND
1922
A. W. CUTLER

following pages
FIJI ISLANDS, MELANESIA
1995
JAMES L. STANFIELD

EL MEZQUITAL,
GUATEMALA
1988
JAMES NACHTWEY

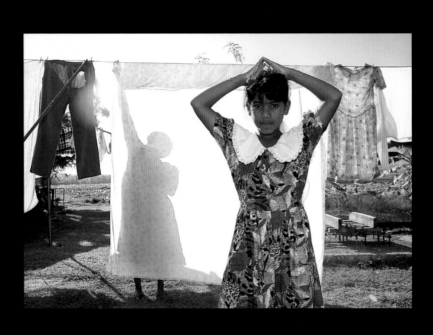

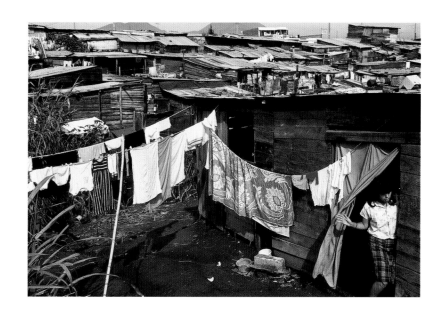

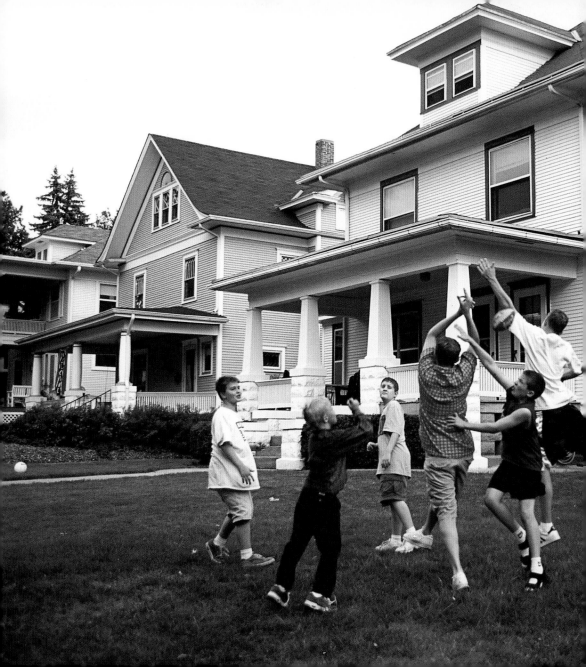

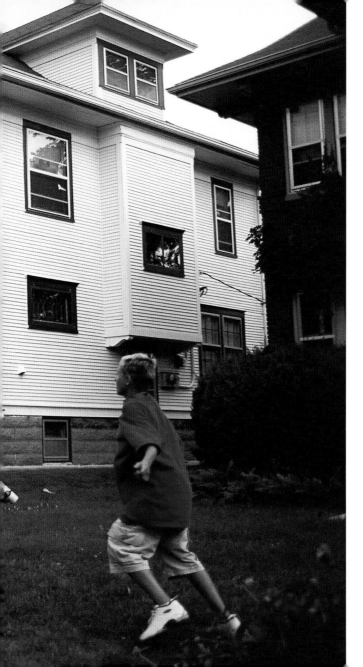

LINCOLN, NEBRASKA
2000
JOEL SARTORE

following pages
WEST FALKLAND
1988
STEVEN L. RAYMER

POLTAVSKAYA, RUSSIA
DATE UNKNOWN
GERD LUDWIG

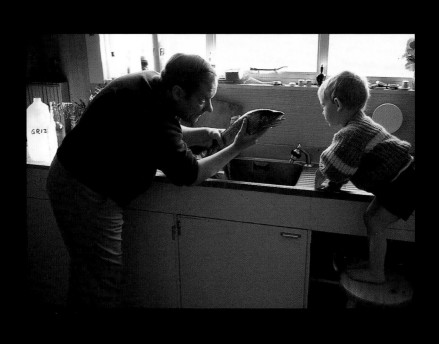

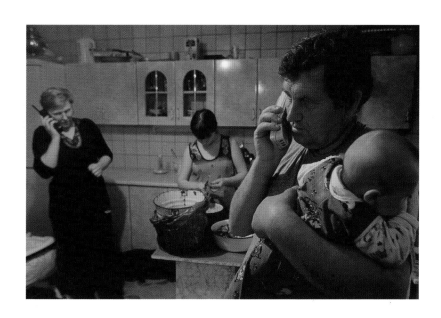

BOA VISTA, BRAZIL
1997
JOEL SARTORE

following pages
MOCORON RIVER,
HONDURAS
1983
DAVID ALAN HARVEY

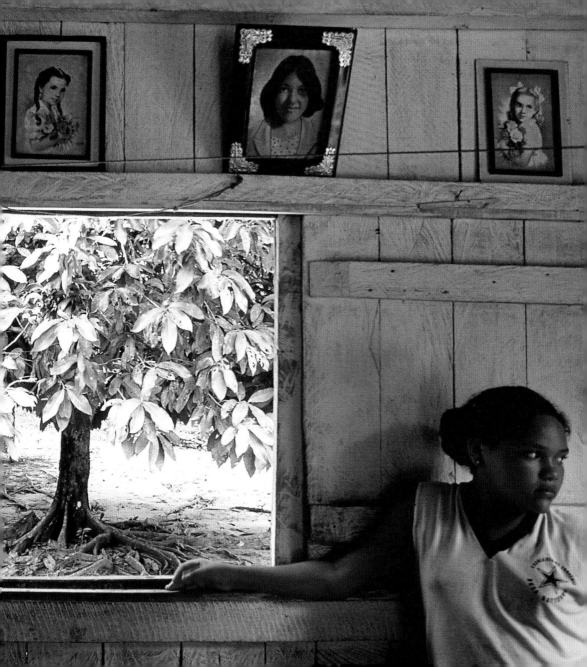

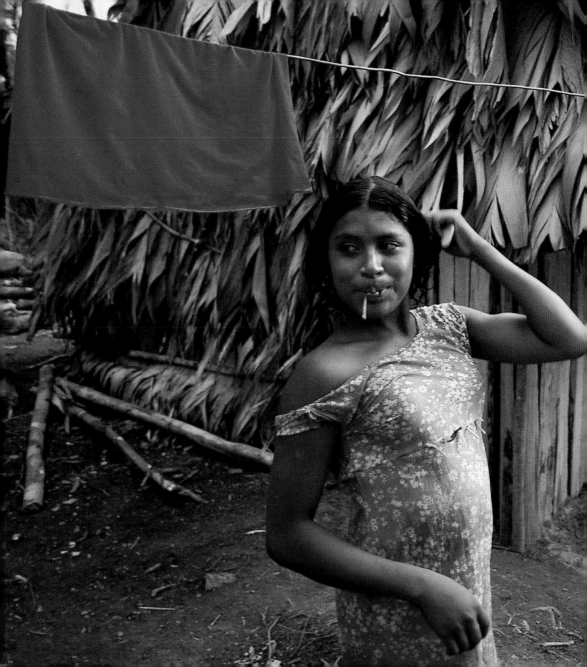

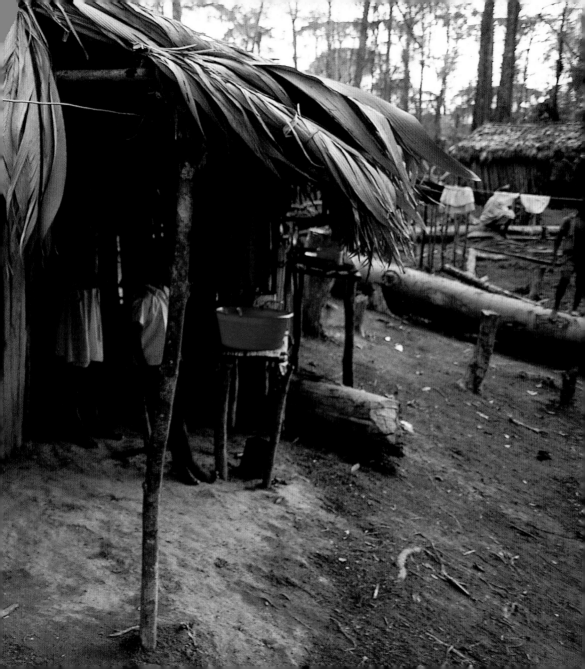

LINCOLN, NEBRASKA
2000
JOEL SARTORE

following pages
KRYVORIVNYA, UKRAINE
1997
LIDA SUCHY

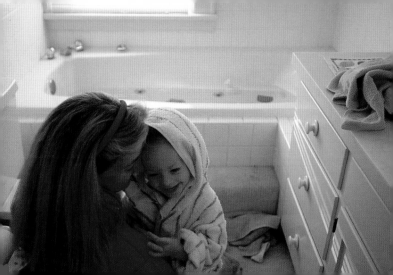

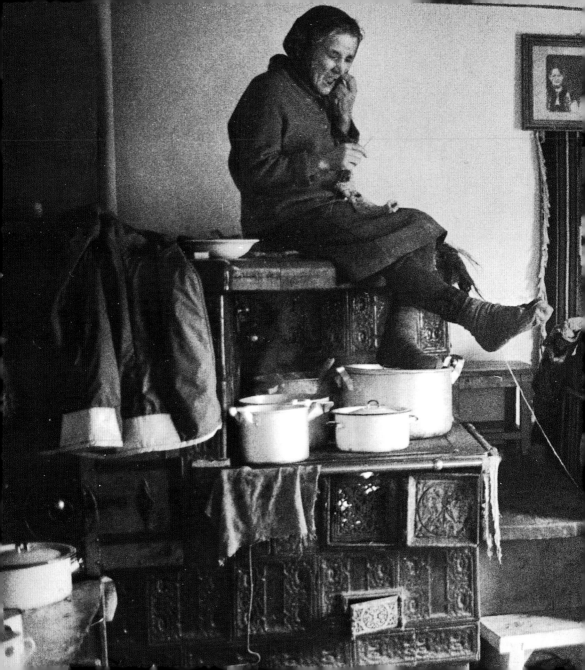

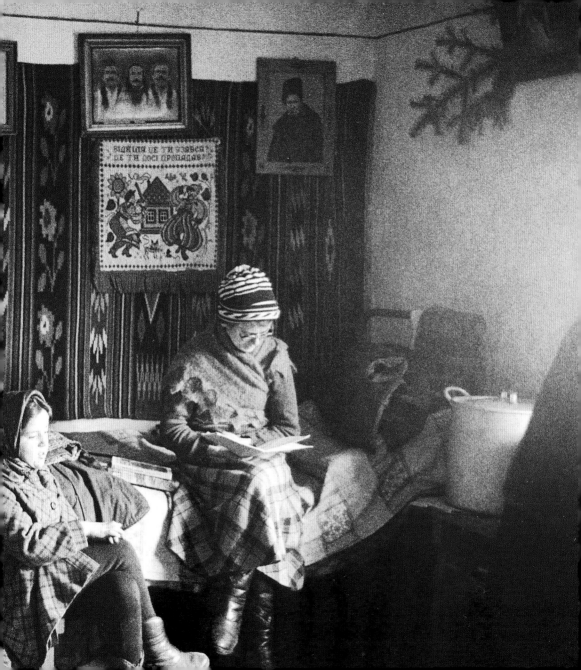

WISDOM, MONTANA
1975
WILLIAM ALBERT ALLARD

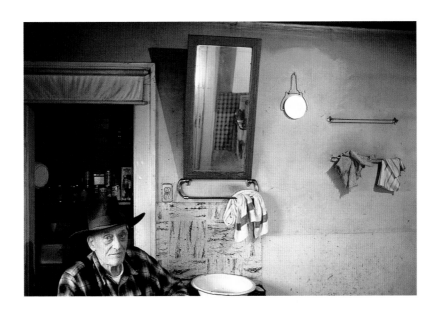

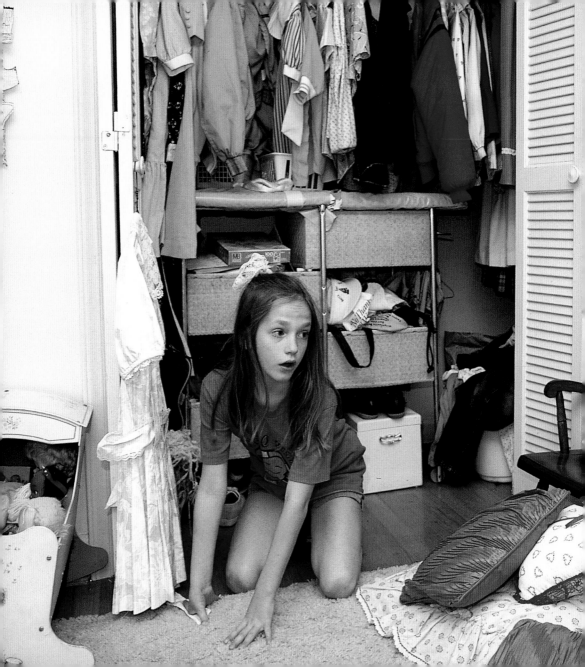

NORTH CAROLINA
1988
PAM SPAULDING

following pages
XINJIANG, CHINA
1996
REZA

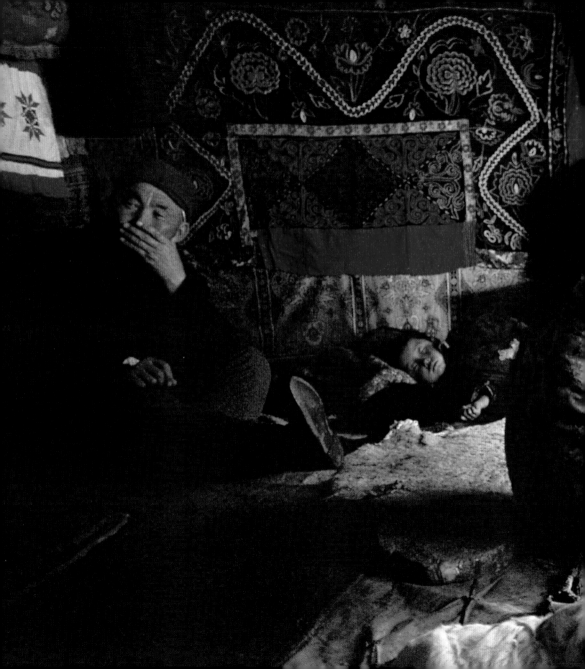

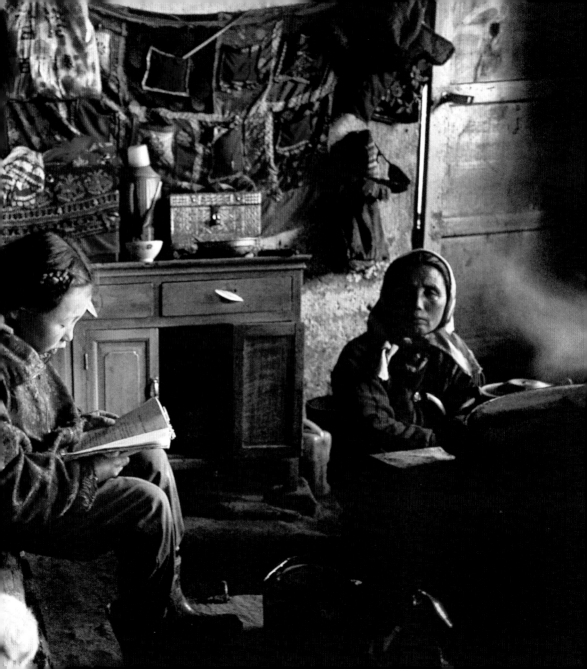

QUIANDEUA, BRAZIL
1997
JOEL SARTORE

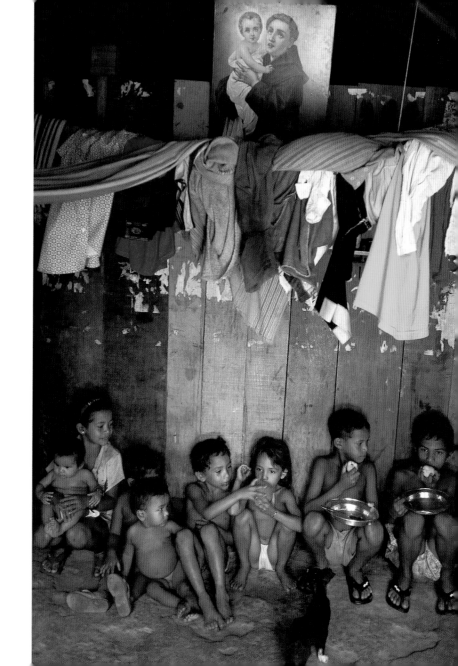

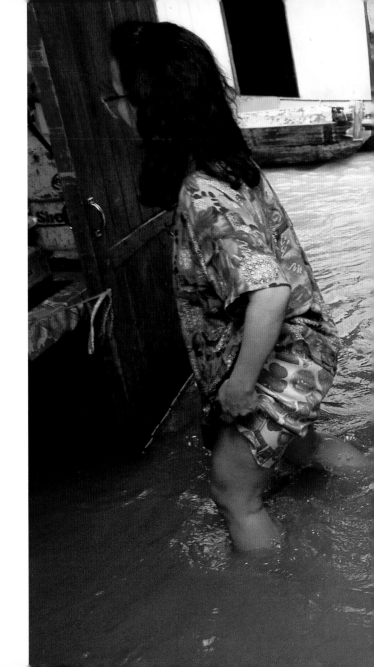

MALAYSIA
1997
STUART FRANKLIN

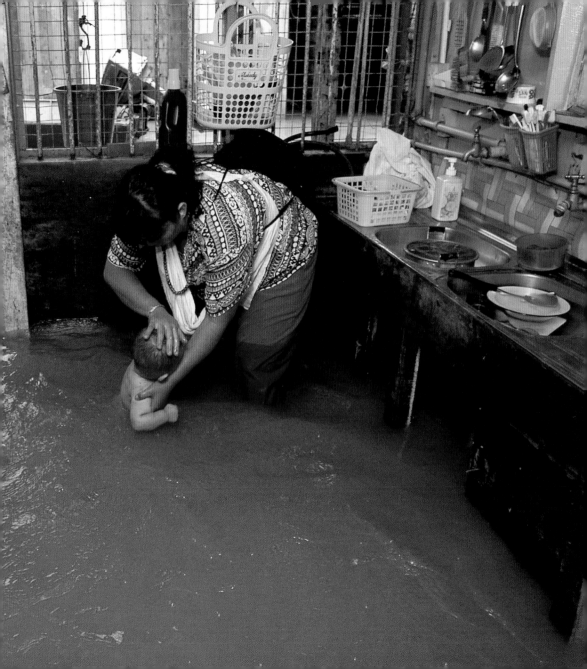

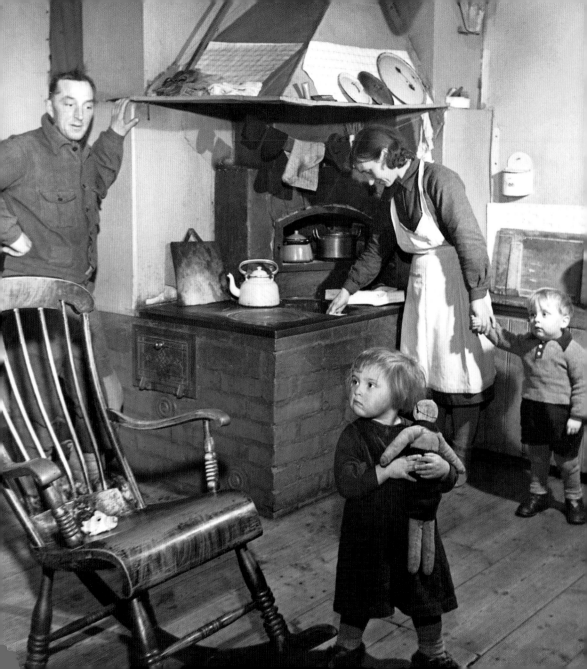

GULKRONA ISLAND,
FINLAND
1947
JERRY WALLER,
AMERICAN
RED CROSS

Hanging around the house may

be, in the end the greatest of luxuries. Whether napping with your infant beside you, or having a family picnic in the backyard, or watching TV, the simple act of being surrounded by home and family is enough. When the work is done and the day is behind you, there is, as the saying goes, no place like home. ⚘

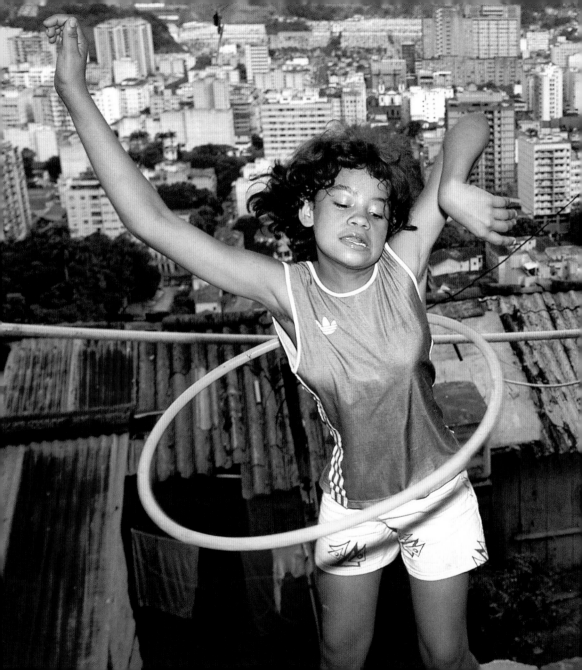

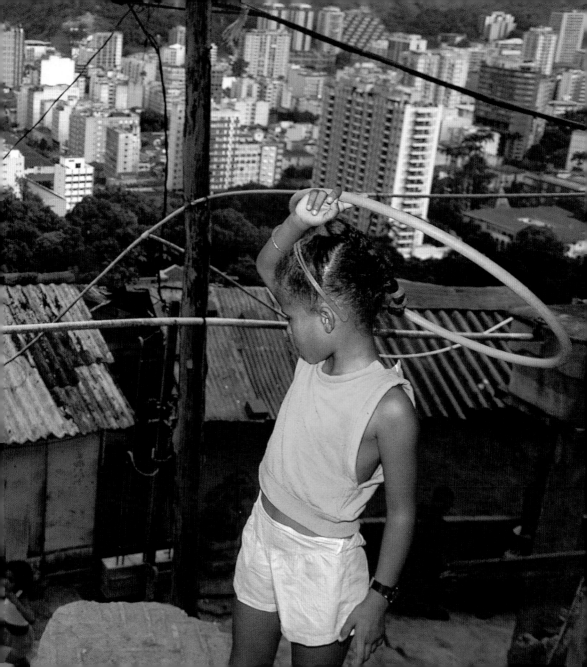

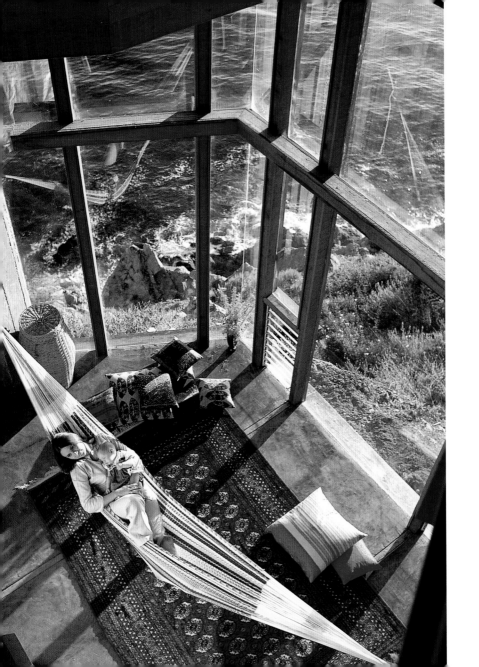

BIG SUR, CALIFORNIA
1972
TOMAS W. SENNETT

preceding pages
SANTA MARTA, BRAZIL
1988
MARY ELLEN MARK

following pages
THE OZARKS, KANSAS
1946
WILLARD R. CULVER

SANTIAGO DE CUBA,
CUBA
1999
DAVID ALAN HARVEY

OKLAHOMA
1984
CHRIS JOHNS

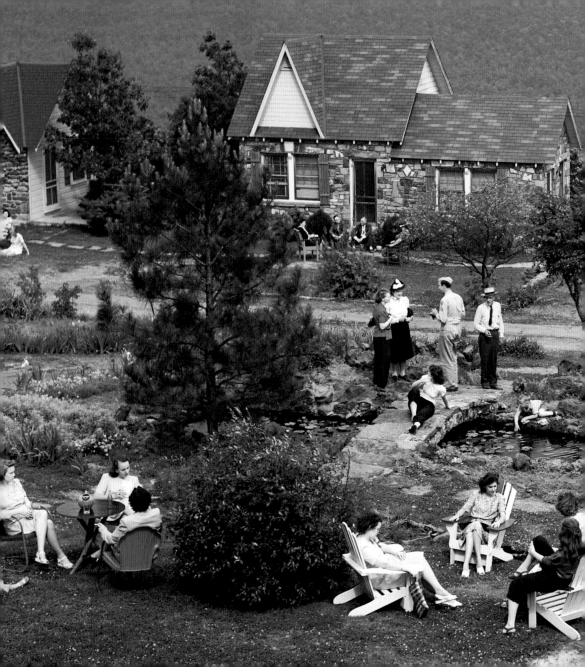

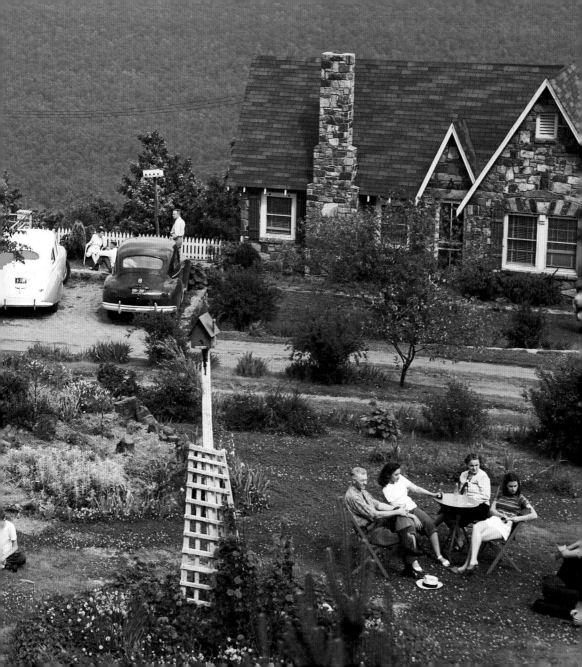

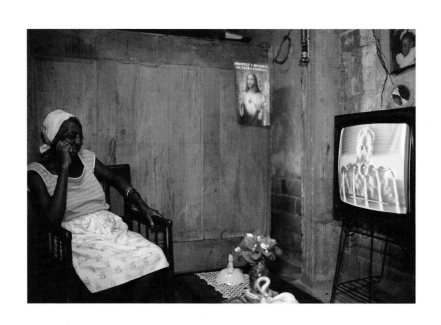

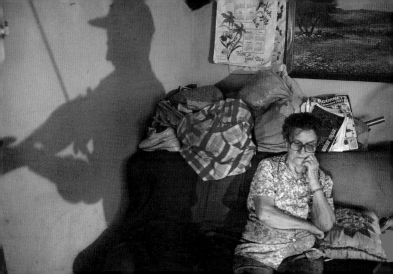

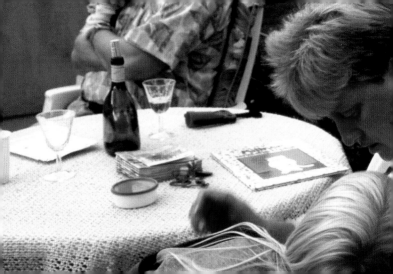

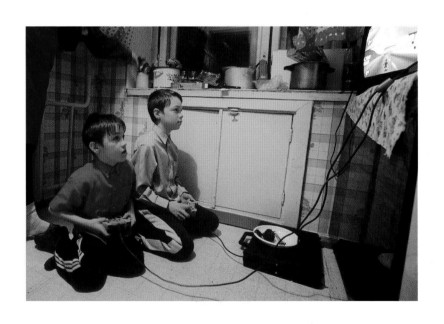

BERLIN
1996
GERD LUDWIG

preceding pages
BERLIN
1996
GERD LUDWIG

CLOVIS, CALIFORNIA
2001
SARAH LEEN

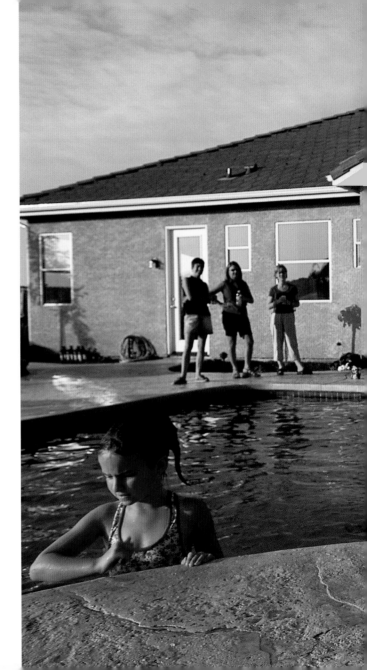

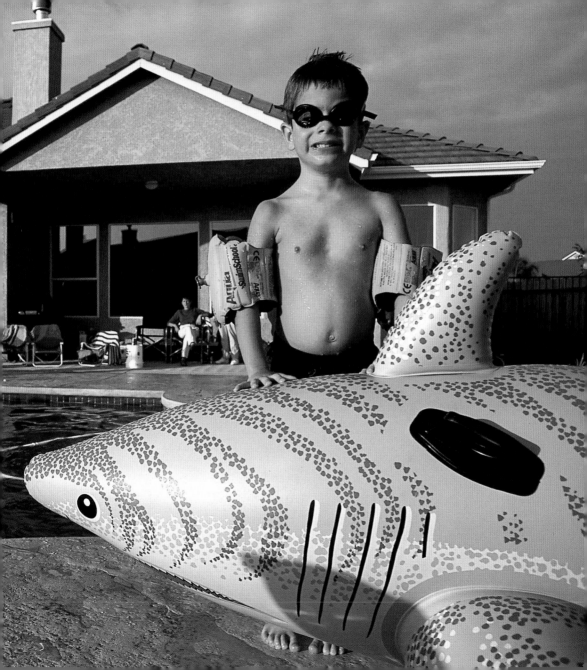

BELLE MEADE
PLANTATION, NASHVILLE,
TENNESSEE
1996
RAYMOND GEHMAN

following pages
SALT LAKE CITY, UTAH
1996
JOEL SARTORE

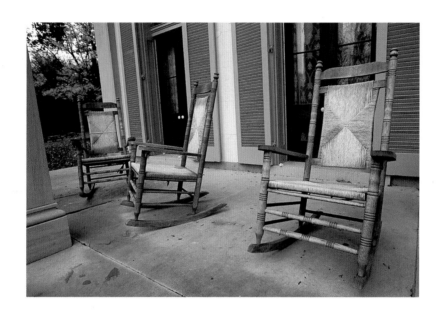

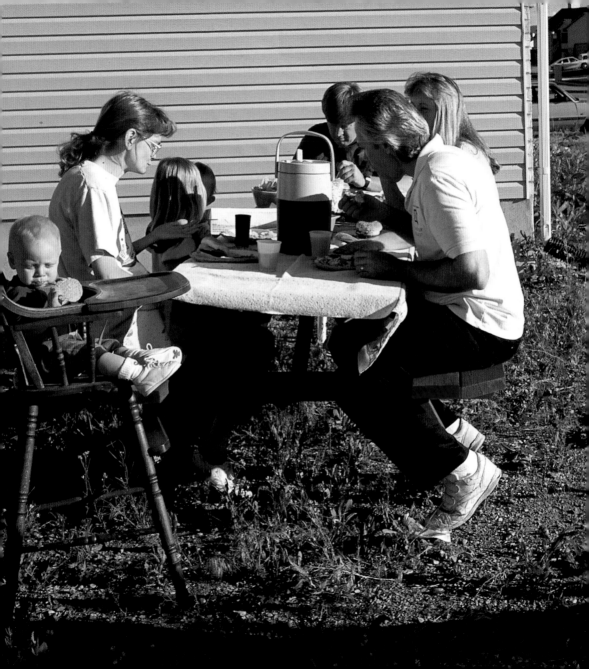

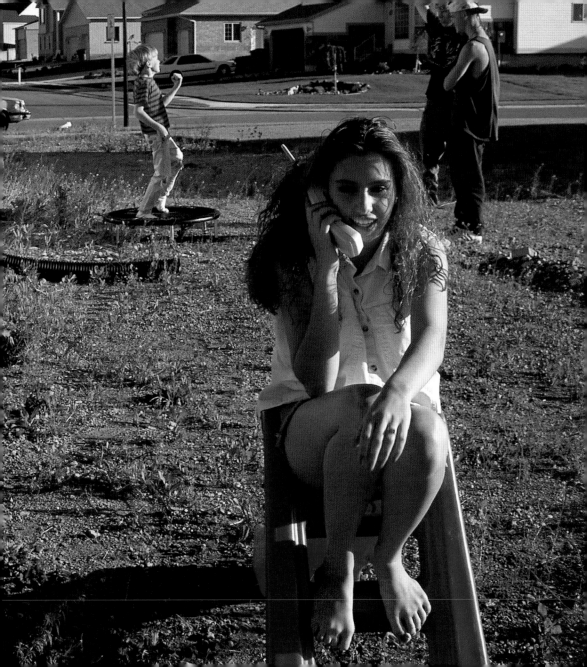

PABELAN, JAVA,
INDONESIA
1989
CHARLES O'REAR

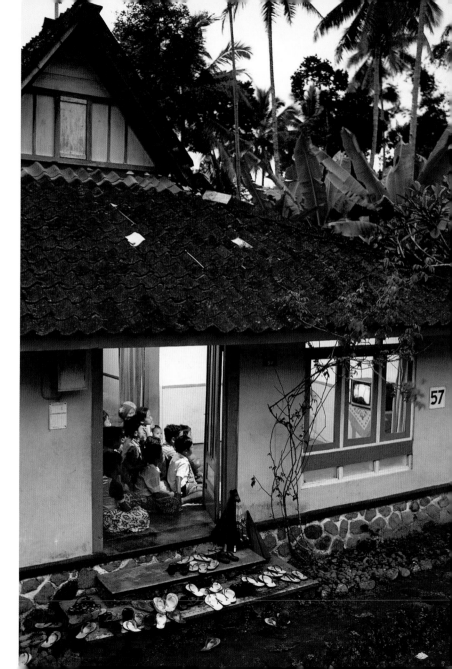

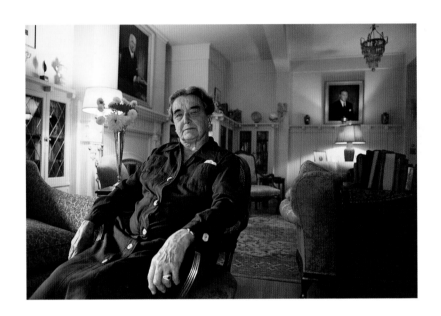

SAN MATEO, CALIFORNIA
1981
JAMES A. SUGAR

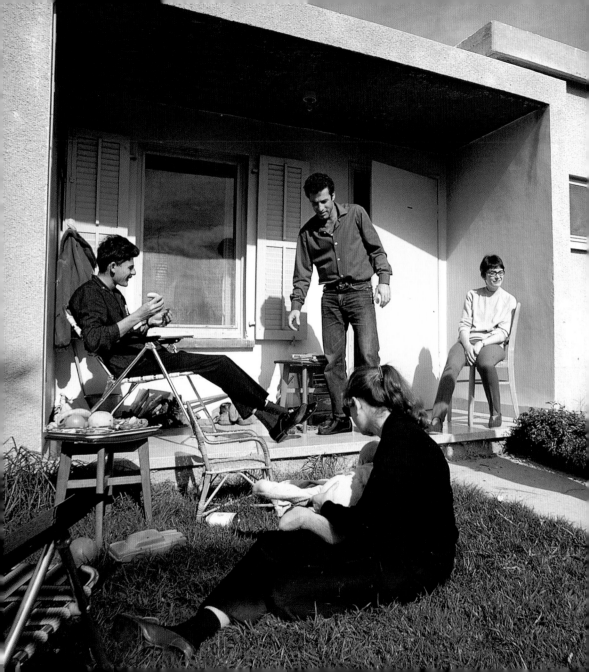

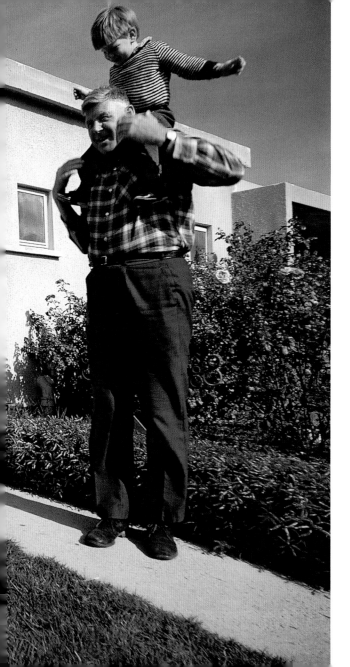

HA ON KIBBUTZ,
ISRAEL
1970
AL ABRAMS

following pages
VIETNAM
1981
STEVE WALL

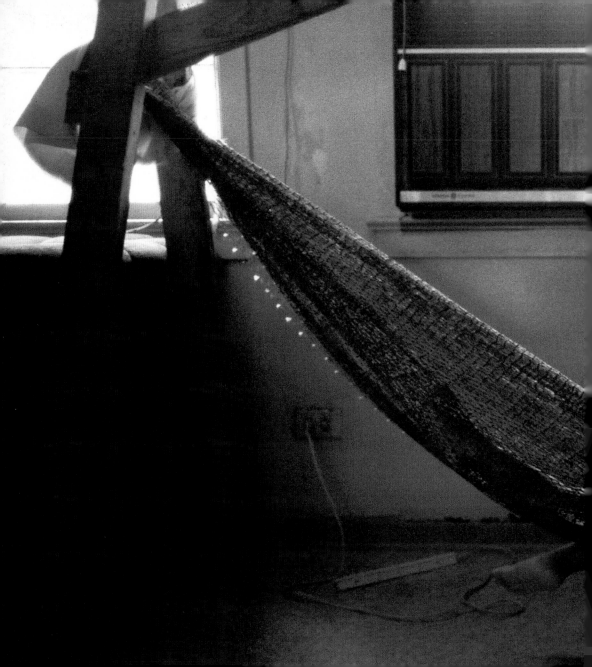

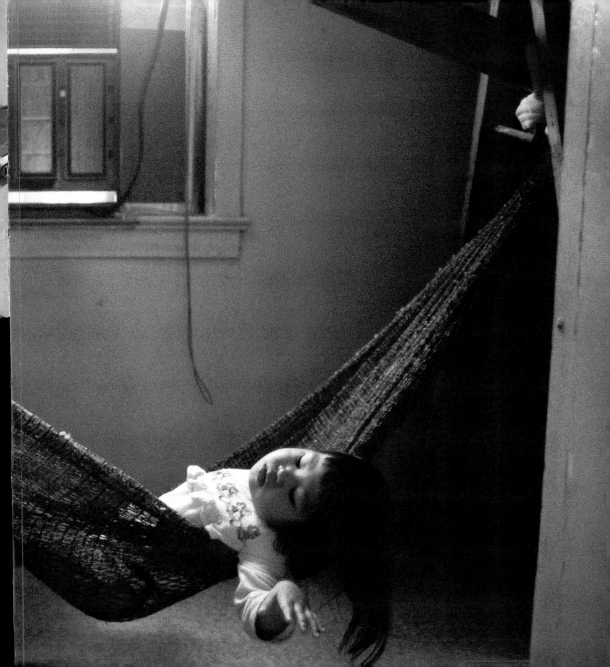

Home
by K. M. Kostyal

Published by the National Geographic Society
John M. Fahey, Jr., *President and Chief Executive Officer*
Gilbert M. Grosvenor, *Chairman of the Board*
Nina D. Hoffman, *Executive Vice President*

Prepared by the Book Division
Kevin Mulroy, *Vice President and Editor-in-Chief*
Marianne R. Koszorus, *Design Director*
Leah Bendavid-Val, *Editorial Director, Photography Books*

Staff for this Book
Leah Bendavid-Val, *Editor*
Rebecca Lescaze, *Text Editor*
Peggy Archambault, *Art Director*
Vickie Donovan, *Illustrations Editor*
Melissa Hunsiker, *Assistant Editor*
Joyce M. Caldwell, *Text Researcher*
R. Gary Colbert, *Production Director*
John T. Dunn, *Technical Director, Manufacturing*
Richard S. Wain, *Production Project Manager*
Meredith C. Wilcox, *Illustrations Assistant*

We would like to give special thanks to Susan E. Riggs,
Bill Bonner, Brian Drouin, and Patrick Sweigart for their
hard work and generous support for this project.

One of the world's largest nonprofit scientific and edu-
cational organizations, the National Geographic Society
was founded in 1888 "for the increase and diffusion of
geographic knowledge." Fulfilling this mission, the Soci-
ety educates and inspires millions every day through its
magazines, books, television programs, videos, maps
and atlases, research grants, the National Geographic
Bee, teacher workshops, and innovative classroom mate-
rials. The Society is supported through membership dues,
charitable gifts, and income from the sale of its educa-
tional products. This support is vital to National Geo-
graphic's mission to increase global understanding and
promote conservation of our planet through exploration,
research, and education.

For more information,
please call 1-800-NGS LINE (647-5463)

or write to the following address:

1145 17th Street N.W.
Washington, D.C. 20036-4688 U.S.A.

Visit the Society's Web site
at www.nationalgeographic.com.

Front cover and page 3: Venice/1990/Todd Gipstein

Additional Credits: Cover and pp. 3, 35, 109, 113, NGS Image Collection; pp.16-17,
Woodfin Camp & Associates